IMAGES
of America

ALBANY
STORIES FROM THE VILLAGE BY THE BAY

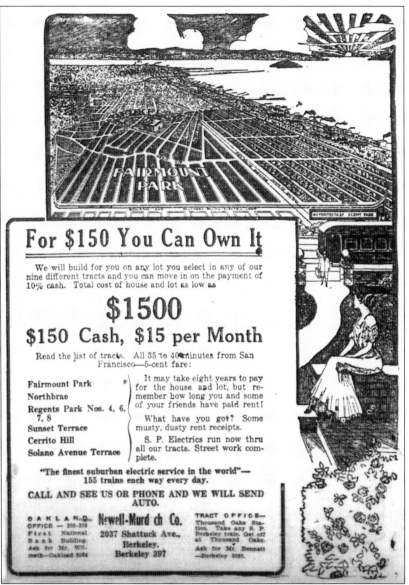

In the early 1900s, Albany was mostly open fields, but East Bay developers were eager to sell property that had been subdivided after the San Francisco earthquake. This real estate ad from 1912 promotes lots in several Albany subdivisions, including Fairmount Park, Regent's Park, Sunset Terrace, and Cerrito Hill: "Total cost of house and lot as low as $1,500. . . . It may take eight years to pay for the house and lot, but remember how long you and some of your friends have paid rent!" Access to convenient train lines was emphasized: "The finest suburban electric service in the world . . . 35–40 minutes from San Francisco—5 cent fare." It was not long before the lots were sold and the fields became a city of homes. (Courtesy of UC Berkeley.)

ON THE COVER: This 1915 photograph of the intersection of San Pablo and Solano Avenues captures a Southern Pacific electric train at the Albany station, a Key System streetcar on San Pablo, and the Albany Drug Store, the first store on the northeast corner of the intersection. (Courtesy of Western Railway Museum Archives.)

IMAGES
of America

ALBANY
STORIES FROM THE
VILLAGE BY THE BAY

Karen Sorensen

To Mike Zawadski,
I hope you enjoy taking
a look back at Albany!

Karen Sorensen

ARCADIA
PUBLISHING

Published by Arcadia Publishing
Charleston, South Carolina

Printed in the United States of America

Library of Congress Control Number: 2019949293

For all general information, please contact Arcadia Publishing:
Telephone 843-853-2070
Fax 843-853-0044
E-mail sales@arcadiapublishing.com
For customer service and orders:
Toll-Free 1-888-313-2665

Visit us on the Internet at www.arcadiapublishing.com

CONTENTS

ACKNOWLEDGMENTS

A city history book would not be possible without the help of the community, and there are many people from both Albany and surrounding communities to thank for supporting this publication. Sincere appreciation goes to the Albany Library, especially library manager Rachel Sher and Paul Straghalis. The library is not only a source of historical information but also an extensive historical photograph collection. The Albany Historical Society also supplied information and many photographs. Thanks go to Joan Larson, president; Rochelle Nason, treasurer; and Marsha Skinner, secretary; as well as board members Anthony Golden, Jennifer Hansen-Romero, and Jamie Vislocky.

Many other local/regional organizations contributed photographs and/or information and time, including the El Cerrito Historical Society, Solano Avenue Association, Western Railway Museum Archives, Saint Mary's College High School, SFNO District Archives of the De La Salle Institute, Berkeley Historical Society, Berkeley Architectural Heritage Association, Oakland History Room, UC Berkeley Library, Friends of the Fountain and Walk, Berkeley Public Library, Contra Costa County Historical Society, and Agricultural Research Service-USDA.

Albany is fortunate to have had many wonderful historians over the years, and I am grateful for their efforts. Catherine Webb, founder of the original Albany Historical Society; former fire chief Gerald Browne; the Albany Fire Department; and the Albany Police and Fire Employees Civil Service Club did much to preserve the city's history, both through photograph collections and previous history books. William Woolworth authored a comprehensive school history, included in Catherine Webb's *Stories of Albany*. Additional helpful information comes from Richard Schwartz's book about M.B. Curtis, *The Man Who Lit Lady Liberty*.

I also extend enormous thanks to the many individual community members who contributed to this publication: Frederika Adam, Ed Clausen, Carly Dennett, Doug Donaldson, Anthony Golden, the Hansen family, Jerri Holan, Ron Hook, the Marengo family, Kelly Neylon, Chris Treadway, Bob Willson, and Gail Van Winkle Lydon. Much appreciation also goes to the many Albany businesses, organizations, and city departments—too numerous to list—that contributed to Albany's history by appearing in this publication. I am also indebted to several individuals who provided helpful advice and reviews, including Tom Panas of the El Cerrito Historical Society; Phil Gale of the Berkeley Historical Society; and Dr. Beverly Ortiz, cultural services coordinator with the East Bay Regional Park District.

Finally, much love and gratitude go to my family members who, as always, provided much appreciated support during the preparation of this book.

—Karen Sorensen

This book is not intended to be a comprehensive history of the city of Albany. It is based on a series of historical articles written randomly over a period of time, which focus primarily on the period of history beginning in the late 1800s. Many previously published works comprehensively cover the periods of history applying to native people of the Bay Area, as well as the California Spanish/Mexican settlements that began in the 1700s. It is the author's hope this small book adds to the collective knowledge about local history. A portion of proceeds will be donated to local historical organizations. Portions of the chapter introductions were originally published on the Patch.com page for Albany, California, by the author.

INTRODUCTION

Albany, a small city just 1.7 miles square, has—perhaps, not surprisingly—an intriguing story linked to its birth.

The year was 1908 and the 200–300 residents of what was then called Ocean View faced what they viewed as a David vs. Goliath challenge: how to get Berkeley, an established city of 40,000, to stop using unincorporated Ocean View as a garbage dump. Agitation over the situation was heightened by a regional outbreak of plague—which had only recently appeared in North America—and the sanitation and rat-extermination campaigns that were underway.

When Berkeley ignored Ocean View's opposition, a group of women took up arms and formed a blockade on Buchanan Street to stop the approaching garbage wagons. The event, which made headlines as far away as Los Angeles, temporarily halted the trash deliveries, but a permanent legal solution was still required. After incorporating, Ocean View adopted an ordinance against outside garbage dumping, and spent the next several months enforcing it.

It was a challenging beginning that became a colorful tale told for generations—but stories from the Ocean View / Albany area had started much earlier.

Albany is located in the homeland of the Huchiun, one of many tribes that spoke Chochenyo, a dialect of one of several Ohlone languages. The Huchiun political, social, spiritual, and economic systems enabled them to thrive for generations, with villages and seasonal camps dispersed throughout the East Bay, including the area known today as Albany. They gathered shellfish in the bay, fished in the creeks, and hunted and gathered dozens of different plant and animal foods in the local hills and valleys. The Huchiuns' world was upended by the impacts of Spanish, Mexican, and early American settlement in the area beginning in the 1700s.

In 1820, Luis Maria Peralta, a member of the 1775–1776 Anza expedition, received a vast land grant of approximately 44,800 acres from the Spanish government. His Rancho San Antonio stretched from San Leandro Creek in the south to Cerrito Creek in the north. Eventually, he gave the northern section covering present-day Berkeley and Albany to his son Jose Domingo Peralta. Following the late 1840s Mexican-American War and the influx of Gold Rush settlers, the Peraltas began to lose control of their property.

Just a few decades later, the first industrial uses of the Albany area began when dynamite factories started operating near the waterfront. In 1879, the Giant Powder Company, which had just closed a plant near San Francisco, opened a factory at Fleming's Point (near today's Golden Gate Fields racetrack), hoping to escape the wrath of city dwellers fed up with accidental explosions. However, it was not long before similar death and destruction generated more angst in the East Bay. After years of deadly blasts, Giant and other Albany-area powder plants were forced to close or move elsewhere.

One of the explosions damaged the Albany area's grandest building, the elaborate Peralta Park Hotel, which was built in the late 1880s. However, the hotel's owner, the famous actor M.B. Curtis, soon became just as notorious as the powder plants. Accused of murdering a policeman, he went through multiple controversial trials before he was finally acquitted. Curtis was then forced to sell the hotel before it could open to help pay his legal fees and debts, and the ornate structure became a school instead. Today, the site of the old hotel is the location of Saint Mary's College High School.

At the time Albany incorporated in 1908, issues beyond garbage dumping surfaced for the small town, challenging its existence. The city's initial proposed boundaries included an unincorporated area near today's Berkeley Northbrae neighborhood that developers and Berkeley business interests had earmarked for a proposed new state capital site. The conflict generated headlines as Berkeley protested Ocean View's plans.

Another challenge once incorporation was achieved was how to finance the operation of the city in a sparsely populated rural community. When Ocean View tried to bolster its meager city finances with fees from poolrooms—gambling establishments that were controversial at the time—headlines erupted again.

Despite its initial struggles, the city began to take hold. In the fall of 1909, Ocean View changed its name to Albany to honor the birthplace (Albany, New York) of its first mayor, Frank Roberts. Like other East Bay cities, Albany was expanding and absorbing those fleeing San Francisco after the 1906 earthquake. Developers laid out large housing tracts, financed a system of local electric trains and streetcars, and touted Albany as "The Bungalow City."

Efficient transportation via the interurban railways spurred growth in Albany and across the East Bay. One realtor, the Newell-Murdoch Co., ran a newspaper ad in 1912 promoting real estate in the Albany and Northbrae areas. Like many ads, it highlighted train service: "All [tracts] 35 to 40 minutes from San Francisco. . . . The finest suburban electric service in the world."

As Albany's population increased, rural life shifted to suburban life, and new schools, firehouses, and city infrastructure were required. By the 1920s, well-known East Bay builder Charles MacGregor began constructing homes in Albany. Throughout the next two decades, MacGregor added more than 1,500 homes to the community, greatly influencing its character, and for many years the city celebrated MacGregor Day every September. Albany Hill, which has had various names over the years, developed more slowly than the rest of the city. After a number of controversial development proposals were rejected, a combination of park land, open space, and housing emerged on the hill.

The development of the public schools played a major role in Albany from the start, with the school district organizing before the city's incorporation. As Albany expanded, so did the schools: from a single classroom in a barn to today's highly rated district with seven schools. At one point in the late 1920s, Albany nearly became part of Berkeley because the city lacked a high school. But Albany voters rejected annexation, and the city found a way to build its own high school and retain its independence.

For years, the city gathered to celebrate on the Fourth of July, building floats and turning out for a large community parade. Eventually, this gave way to the now-famous Solano Stroll, a September parade and street fair that stretches a full mile along Solano Avenue from Berkeley to Albany. The Stroll began in the 1970s as a small sidewalk sale at the east end of Solano Avenue, developing into the major regional event of today that attracts 200,000-plus people.

Despite its small physical size, Albany has continued to expand. The population increased from 16,444 in 2000 to 18,539 in 2010 and is predicted to grow to approximately 20,000 by 2020. Yet Albany maintains its family-friendly small-town atmosphere—a constant since 1908—while offering the culture and conveniences of a major metropolitan area. The result is a city that most agree lives up to its motto: "Urban Village by the Bay."

One

THE EXPLOSIVE EARLY YEARS

It was a windy, brisk afternoon in January 1883 and the workers in the dynamite packinghouses of Giant Powder Company were cold.

The foreman ordered one of the workers to rake the fire under a nearby boiler that supplied heat, and add more coal. As this task was carried out, a gust of wind blew a hot coal into a transport car filled with loose powder. The result was a chain reaction: the transport car exploded, followed by the packinghouses—a half dozen of them—one by one. The workers took shelter in the mixing house, but unfortunately this structure blew up next.

Down at the wharf, the driver of a wagonload of dynamite jumped into the water seconds before the wagon exploded. Then, burning brands from the mixing house set one of the schooners afire while it was being loaded with dynamite. Workers quickly scattered, except for one, who ran out with a sack and miraculously beat out the flames on the dynamite boxes—this would be the only good news of the day.

A total of 37 Chinese workers, as well as the assistant superintendent, were killed, and nearly all of the plant was destroyed.

This was not the first explosion at Fleming's Point (site of today's Golden Gate Fields racetrack), and it would not be the last, but it aptly demonstrates the dangers associated with the powder plants located in the Albany area during the late 19th and early 20th centuries.

Dynamite manufacturing began in America 16 years earlier when the Giant Powder Company licensed the patent of Swedish chemist Alfred Nobel and began operating near San Francisco. In fact, for many years, "giant powder" was a synonym for dynamite in the United States.

Dynamite was essential to both gold mining operations and construction in California, including the building of railroads and dams. Finding a suitable location to manufacture it, however, was problematic as the factories had a habit of blowing up.

Giant Powder had two locations in the San Francisco area (Glen Canyon and the sand dunes south of today's Golden Gate Park) before explosions and the resulting opposition forced it to move elsewhere. In 1879, the company relocated to Fleming's Point along today's Albany shoreline. At the time, this area was quite rural and considered far removed from the major cities of Oakland and San Francisco.

Unfortunately, the accidents continued. Operations lasted barely six months before a major explosion killed over 20 employees, destroyed six buildings and damaging other structures outside the plant.

Giant rebuilt and operated successfully until the 1883 explosion. After this calamity, it rebuilt more extensively, incorporating a number of safety enhancements. However, the location, which also housed a chemical manufacturing plant, was becoming congested by the 1890s and more vulnerable.

On the morning of July 9, 1892, a large explosion occurred in the nitroglycerine house where workers were cleaning up. Another six explosions followed, which, along with several fires, leveled both the powder and chemical plants. Five men were killed outright, a boy was blown through a roof, and another man was hurled into the bay. More than a dozen others were injured.

The accident, which the general foreman of the plant later claimed involved more than a million pounds of explosives, was one of the largest that ever occurred in the Bay Area. It caused substantial damage in Berkeley and Oakland, broke numerous windows in San Francisco and, according to some reports, shattered glass in Sonoma and was even felt in Sacramento.

A *New York Times* article described the event: "There was a terrific explosion this morning at the works of the Giant Powder Company in West Berkeley across the bay from San Francisco. Seven distinct shocks were felt and 300 tons of giant powder brought death and destruction to the immediate neighborhood and caused great damage to Oakland and San Francisco. People for some moments, in both cities, were panic stricken.

"Immediately after the explosion, the town of West Berkeley from a distance resembled the site of an actual volcano. Dozens of private houses in the vicinity were partially destroyed and all along the road from Oakland to West Berkeley Station were damaged buildings."

Giant was forced to relocate farther away and found a more suitable location by merging with another company operating at Point Pinole.

Meanwhile, relations had strained between Giant and Egbert Judson, a prominent figure in the US dynamite and chemical industry who had helped organize Giant Powder Company and patented some powders. He also ran the Judson and Shepard Chemical Works, which had been located next to the Giant plant at Fleming's Point and supplied the plant with necessary acids.

Giant was unhappy that Judson had begun selling powders it felt competed with its own. When Giant began manufacturing its own acids around 1890, Judson responded by selling his interest in the company and starting his own dynamite business, which he established on the north and west sides of Albany Hill.

Here, the Judson Dynamite and Powder Company—later acquired by DuPont—operated explosion-free for several years. However, in September 1898, the company began manufacturing gelatin dynamite. One month later, its gelatin mixing house blew up, killing the plant's superintendent. The firm immediately rebuilt the mixing house, but it was destroyed again by another explosion after operating for just two days. Finally, its third attempt was successful.

It was during the time of dynamite explosions that eucalyptus trees—still present today—were planted on Albany Hill in an attempt to buffer surrounding communities from the blasts.

The Judson plant manufactured dynamite on the hill until 1905, when a chain of explosions rocked the area and set fire to several buildings, rousing the ire of local residents. The plant was then dismantled and the property sold.

This would be the last of the great dynamite blasts in the Albany area, where the era of high explosive disasters had finally come to a close.

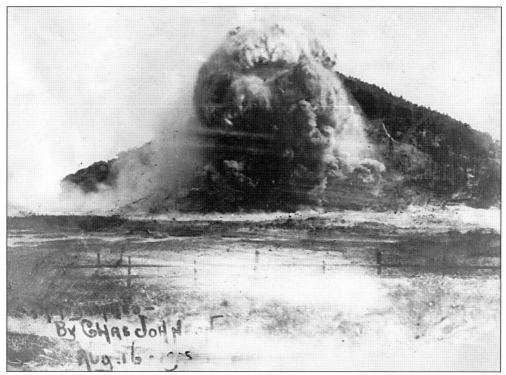

This 1905 photograph captured a massive explosion at the Judson Dynamite and Powder Company. The plant operated on the northwest side of Albany Hill for approximately 15 years and, at the time it was established, was one of the largest powder works on the West Coast. (Courtesy of Albany Library Historical Collection.)

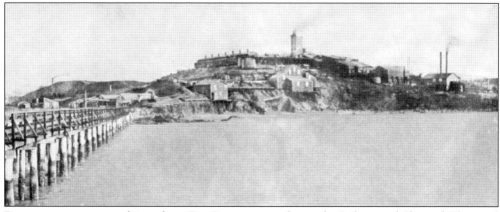

Due to numerous complaints from San Francisco residents, the Judson and Shepard Chemical Works moved from the city to Fleming's Point (pictured here), the site of today's Golden Gate Fields Racetrack, in 1878. The plant supplied Giant Powder Company, which moved to Fleming's Point the next year, with acids used in production. (Courtesy of Albany Library Historical Collection.)

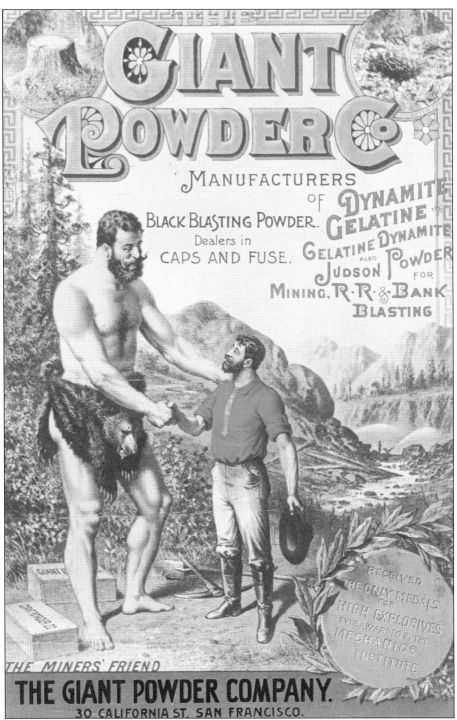

This late 1800s ad for the Giant Powder Company includes the slogan "The Miners' Friend." Dynamite and powders produced by the company were used for California gold mining, as well as construction projects like railroad and dam building. (Courtesy of Contra Costa County Historical Society.)

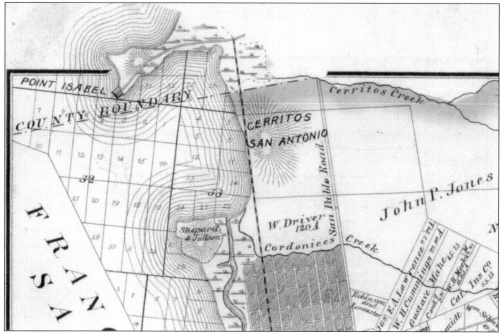

The Judson and Shepard Chemical Works is identified at Fleming's Point on this 1878 map. The large slough and marsh near the point is depicted, and to the north is El Cerrito de San Antonio (the early Spanish name of Albany Hill). Large landowners in the Albany area included W. Driver and John P. Jones, the latter a mining millionaire and US senator from Nevada. (Courtesy of David Rumsey Collection.)

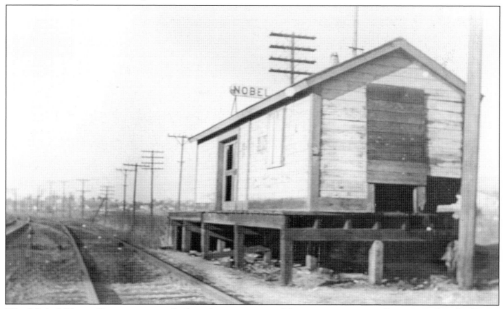

The Nobel Train Station, named after the inventor of dynamite, was on the west side of Albany Hill and was used as a loading platform by explosives manufacturing companies. By 1930, the station was abandoned and was the site of a famous train robbery involving the notorious Frank Smith Gang. (Courtesy of Albany Library Historical Collection.)

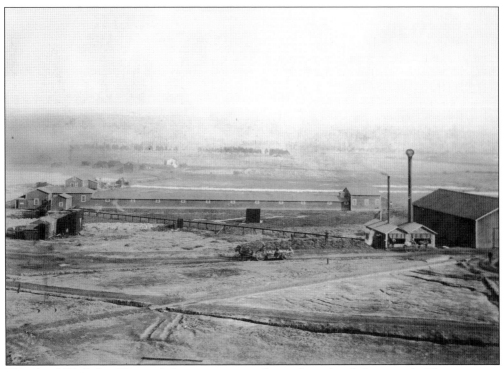

The "Acid Works" at Fleming's Point appears in this early undated photograph. The waterway barely visible in the background is likely the slough that ran south from the point and east of the manufacturing site. (Courtesy of Albany Library Historical Collection.)

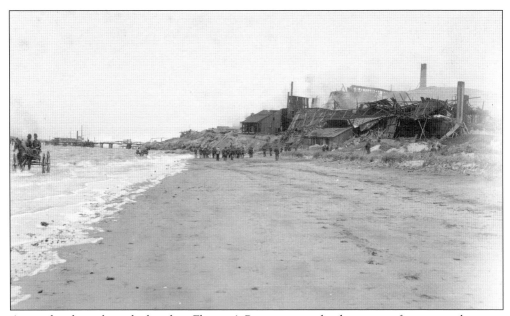

A crowd gathers along the beach at Fleming's Point to view the destruction from an explosion at the Giant Powder Company, which first came to the Albany area in 1879. This 1883 blast killed the plant's superintendent and more than 30 Chinese workers. (Photograph by the author.)

The 1892 explosion at the Giant Powder Company on Fleming's Point was one of the largest that occurred in the Bay Area and made front page headlines in many newspapers (right, the *Oakland Tribune*; below, the *San Francisco Call*). The blast and resulting "air wave" shattered windows all over the East Bay, across the bay in San Francisco, and, according to some reports, as far away as Sonoma. (Both, courtesy of UC Berkeley.)

SIXTH
EXTRA!

BLOWN UP.

The Giant Powder Works Are in Ruins.

A Frightful Explosion Shortly After Nine O'clock.

The Workmen Stricken Down in the Midst of Their Labors.

The Scene of the Disaster Is at Highland Station, Near West Berkeley.

BLOWN SKY HIGH.

Disastrous Explosion at the Judson Powder Works.

SAN FRANCISCO SHAKEN UP.

Five Men Killed and More Than Twice That Number Injured.

GREAT DESTRUCTION OF PROPERTY.

West Berkeley, East Berkeley, Temescal and Oakland Suffer Severely.

THE AIR-BLAST WAS FELT MILES AWAY.

A Crater Left on the Site of the Big Magazine Thirty Yards Wide and Eighty Feet Deep.

The Examiner.

SAN FRANCISCO: SUNDAY MORNING, JULY 10, 1892.

BEFORE AND AFTER THE ACCIDENT.

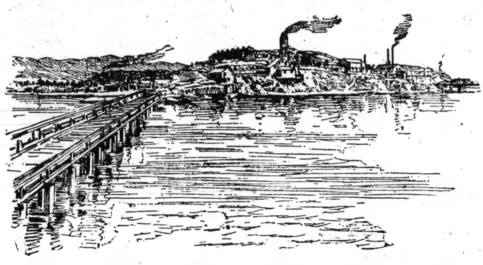

THE POWDER WORKS AND CHEMICAL WORKS BEFORE THE EXPLOSION, AS SEEN FROM THE BAY.
[From a recent photograph.]

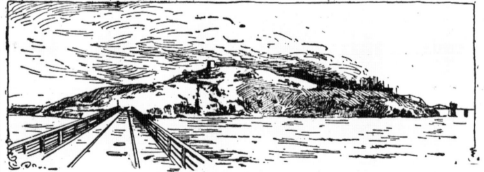

WHAT WAS LEFT OF THE POWDER WORKS AND CHEMICAL WORKS AFTER THE EXPLOSION. THE WRECK OF THE CHEMICAL BUILDINGS IS BLAZING ON THE RIGHT. ON THE LEFT EVERY VESTIGE OF THE POWDER WORKS HAS BEEN WIPED OUT.
[Sketched by an "Examiner" staff artist.]

The *San Francisco Examiner* devoted its entire front page on July 10, 1892, to the massive explosion that occurred the day before across the bay. Included were these before-and-after illustrations of the chemical and powder factories at Fleming's Point. (Courtesy of UC Berkeley.)

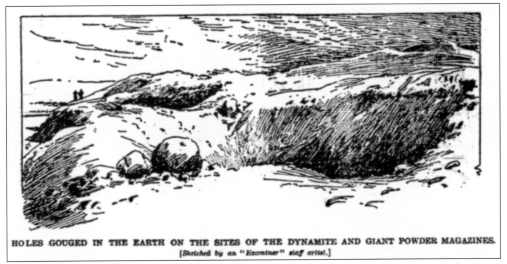

HOLES GOUGED IN THE EARTH ON THE SITES OF THE DYNAMITE AND GIANT POWDER MAGAZINES.
[Sketched by an "Examiner" staff artist.]

The *San Francisco Examiner* coverage included several illustrations of the destruction at the Giant Powder Company in 1892. This drawing depicts the large crater created by the explosion near today's Albany waterfront. (Courtesy of UC Berkeley.)

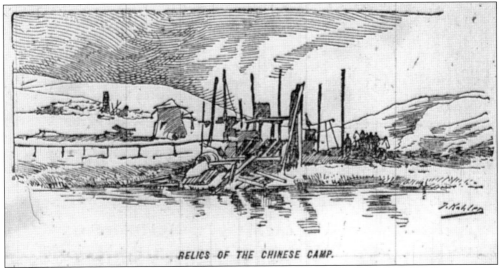

RELICS OF THE CHINESE CAMP.

This drawing in the *San Francisco Call* depicted the ruins of the Chinese camp after the 1892 explosion. Chinese workers were frequently employed for the most dangerous work at dynamite factories in the late 19th century. (Courtesy of UC Berkeley.)

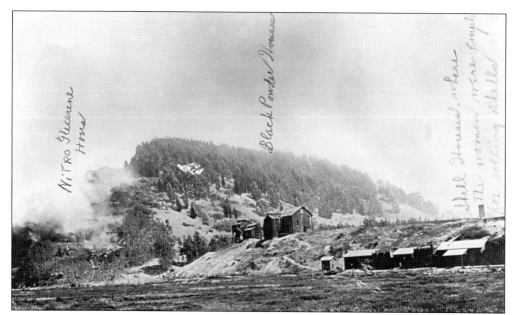

A fire broke out after multiple explosions occurred at the Judson Dynamite and Powder Company on the northwest side of Albany Hill in 1905. Notes on this photograph identify the nitroglycerine house, the black powder houses, and "the shell houses where the women were employed for rolling shells." The explosion, the last in the area that would become Albany, killed the plant's superintendent and damaged local buildings. (Courtesy of Albany Library Historical Collection.)

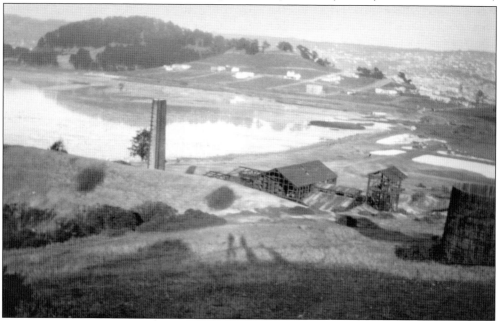

The death and destruction associated with multiple explosions forced the dynamite factories to move out of the Albany area in the early 1900s after a period of 26 years. In this 1930 photograph taken from Fleming's Point, abandoned buildings of the powder and chemical companies appear in the foreground. The background shows the waterfront area before the Eastshore Highway was built. (Courtesy of Albany Library Historical Collection.)

Two

MAURICE CURTIS AND THE PERALTA PARK HOTEL

Open, expansive grasslands, streams meandering from oak-studded hills, a few rural homesteads, and scattered livestock was the scene in the Albany area in the late 19th century. So it must have been a surprise to newcomers to look up and see a palatial, opulent building festooned with turrets and gables looming in the distance over the pastoral setting.

Completed in the early 1890s, the multistory Peralta Park Hotel had 60 bedrooms and 20 bathrooms, and was considered the height of luxury at the time. It was built by Maurice B. Curtis, a famous and flamboyant actor who arrived in Berkeley in the late 1880s and quickly became one of the East Bay's most notable, and later, notorious citizens.

Some years earlier, Curtis—whose real last name was Strelinger—landed the lead role in a play called *Sam'l of Posen* (Posen Avenue in Albany and Berkeley is named after this stage production). The play was so successful that Curtis bought it and toured the country performing with his own theater company, amassing prestige and wealth in the process.

Eventually, he settled in Berkeley, where he began buying up tracts of land and selling them for a profit. Soon, he acquired land near today's Berkeley/Albany border. It was here, at the present site of Saint Mary's College High School, that he built his grand hotel.

Surrounded by gardens, the hotel was well equipped to entertain Curtis's theater and business friends, and utilizing these connections, he sold residential lots in the surrounding area to create a stylish, upscale neighborhood. He and his wife, actress Albina de Mer, built a house near Sacramento and Hopkins Streets. Today, nearby Albina Street bears her name. Curtis called his resort Peralta Park to honor Jose Domingo Peralta, a member of the family that received the 1820 Spanish land grant in the East Bay. Peralta had built an adobe near the area a few decades earlier.

Given his fame and riches, Curtis quickly became one of Berkeley's prominent citizens. Within a few months of his arrival, he became the president of the new Berkeley Electric Light Company, organized a building and loan association, and helped finance a new fire station, named Posen Station, among other ventures. Various accounts of Curtis indicate that not all of his business dealings were honest, yet the charismatic actor was popular.

"I remember Curtis coming to Berkeley," said Berkeley councilman George Schmidt in a 1920 obituary about the actor. "He wore a fine big overcoat and an expensive hat and he walked away with the town. . . . He was the greatest promoter I ever saw. He gave the biggest lunches and dinners at his home, and gathered all kinds of wealthy people from San Francisco there. When he finished feeding them they were ready to buy the world."

To ensure easy access to his hotel, which at the time was in an undeveloped area (much of the hotel site would later become part of Albany), Curtis convinced a local railway company to run a branch horsecar line out Sacramento Street to Hopkins Street, thus connecting the hotel to the more developed areas of Berkeley.

Unfortunately, his resort plans never fully materialized. In 1891, Curtis attended a theater performance in San Francisco. As the night wore on, he began drinking heavily and ended up having a run-in with the police. A scuffle ensued, a shot was fired, and Curtis was accused of murdering a police officer.

Curtis maintained his innocence throughout multiple controversial trials and was ultimately found not guilty. Unfortunately, he was forced to sell his lavish hotel to help pay his debts and the fees associated with his defense. Although he continued acting, even starring in two films, his reputation was never again quite the same. He died a poor man in 1920 at a county hospital in Southern California.

The Peralta Park Hotel was subsequently used for other purposes, including two different schools, until 1903, when the Christian Brothers purchased it and established St. Joseph's Academy for Boys. The Christian Brothers dubbed the building "The Palace."

In 1927, they moved Saint Mary's College High School to the site and used the hotel as a residence hall. Tragically, a 1946 fire, which broke out in one of the building's towers, destroyed the top two floors along with their ornate decorations. The Christian Brothers continued to use the bottom two floors until the building was finally demolished in 1959.

Very little remains today of the original Peralta Park. A large home on Acton Street and a grand Victorian on Albina Street stand out as reminders of the opulent resort and its surrounding chic neighborhood. And, some believe, a lone, towering palm tree on the Saint Mary's College High campus may have once been part of the Peralta Park gardens—a last tribute to Curtis's dream.

Maurice B. Curtis achieved fame and wealth as an actor in the late 19th century. After moving to Berkeley, he became one of the city's prominent citizens, and in the late 1880s he began building the grand Peralta Park Hotel on land that would eventually become part of Albany. (Courtesy of TCS 1.6603, Houghton Library, Harvard University.)

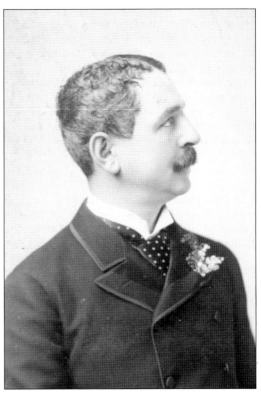

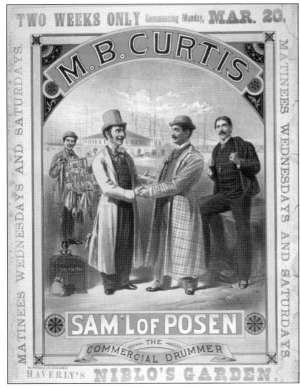

Maurice Curtis rose to fame as the star of the play *Sam'l of Posen*, about a Jewish immigrant. The play was historically significant as it was one of the first times that a Jewish actor portrayed a Jewish character on stage. Curtis toured the country with his company, performing in many different venues. Pictured here is a 19th-century poster advertising the play at Niblo's Garden, a New York theater. (Courtesy of Library of Congress.)

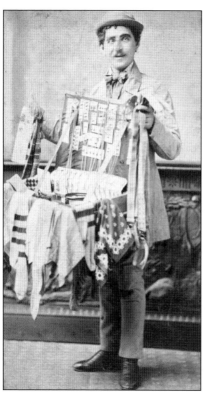

M.B. Curtis poses as Samuel Plastrick, the character of his famous play *Sam'l of Posen*. Plastrick was a commercial "drummer," or traveling salesman. (Courtesy of TCS 1.6595, Houghton Library, Harvard University.)

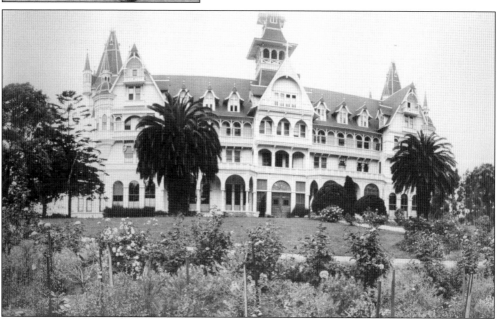

Curtis bought a tract of land near Berkeley's northern border and began building the luxurious Peralta Park Hotel in the late 1880s. Today, the site is the location of Saint Mary's College High School. The large, turreted structure included 60 bedrooms, 20 bathrooms, and lavish gardens. The hotel is pictured here in later years when it was used as St. Joseph's Academy. (Courtesy of SFNO District Archives of the De La Salle Institute.)

The Peralta Park Hotel was Albany's most impressive building and was featured on the cover of this 1913 Fourth of July program, which was also designed to promote the city and attract newcomers. Note the premature announcement that a US naval base would be built in Albany, a claim that proved to be wishful thinking. (Courtesy of Albany Library Historical Collection.)

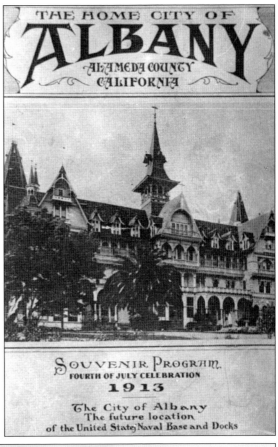

THE HOME CITY OF

ALBANY

ALAMEDA COUNTY
CALIFORNIA

SOUVENIR PROGRAM.
FOURTH OF JULY CELEBRATION
1913

The City of Albany
The future location
of the United States Naval Base and Docks

Towering over the homes of southeast Albany, the Peralta Park Hotel stood out as an opulent addition to the neighborhood in the early 1900s. Open fields and cattle were still part of the landscape. (Courtesy of Albany Library Historical Collection.)

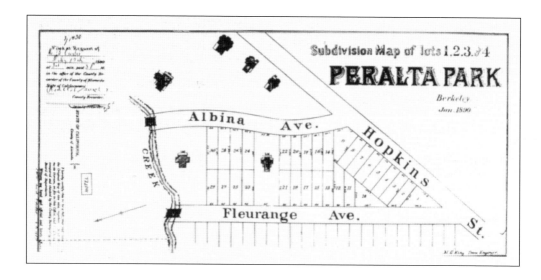

The subdivision map above filed by M.B. Curtis in 1890 shows the surrounding upscale neighborhood Curtis planned as part of his Peralta Park resort. Both Albina and Fleurange Avenues (the latter now Acton Street) were named after Curtis's wife, Maria Alphonsine Fleurange (her maiden name), and Albina de Mer (her stage name). Below, another map filed in 1888 shows other streets in the area, including Posen Avenue (named after Curtis's play) and Curtis Avenue, which later became Monterey Avenue. (The Curtis Street found in Albany/Berkeley today is named after a different early Berkeley landowner.) Other early maps indicate that the southern portion of Ventura Avenue near Posen Avenue was once called Samuel Street, likely named for the main character in *Sam'l of Posen*. (Both, courtesy of Berkeley Architectural Heritage Association.)

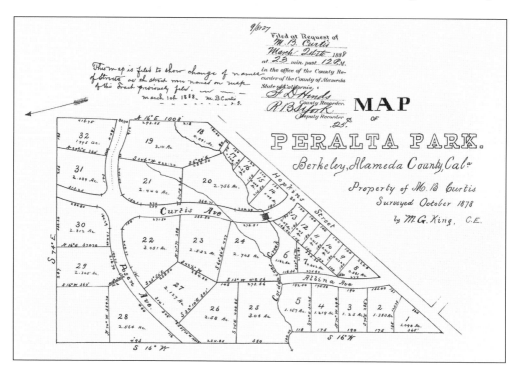

A *San Francisco Chronicle* article from 1894 described the hotel's luxurious interior—including some 100 rooms, elaborate chandeliers, lush carpets, six pianos, and glorious views of the bay—but labeled the building the "great white elephant." Although the structure was completed in 1891, it never opened as a hotel. Curtis sold the property to pay off debts, including legal fees from his murder trials. The building was subsequently used as a school. (Courtesy of UC Berkeley.)

HELD NEVER A GUEST.

The Hotel "Sam'l of Posen" Built.

Peralta Park's Great White Elephant.

Actor Curtis Planned It for a Summer Resort—One Family of Occupants.

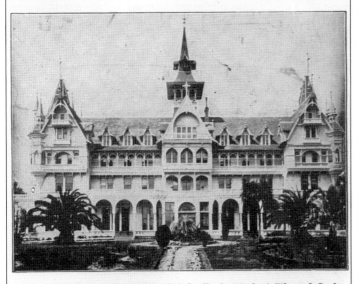

Boarding School In Peralta Park

ST. JOSEPH'S ACADEMY—Originally located at 5th and Jackson, Oakland, 1872 to 1902, it is now situated in Berkeley's Peralta Park District. Brothers and lay teachers instruct 100 resident pupils from the third to the eighth grades.

The Christian Brothers bought the Peralta Park Hotel in 1903. Soon they moved St. Joseph's Academy for boys (originally in Oakland) into the building, which they dubbed "The Palace." (Courtesy of Saint Mary's College High School.)

25

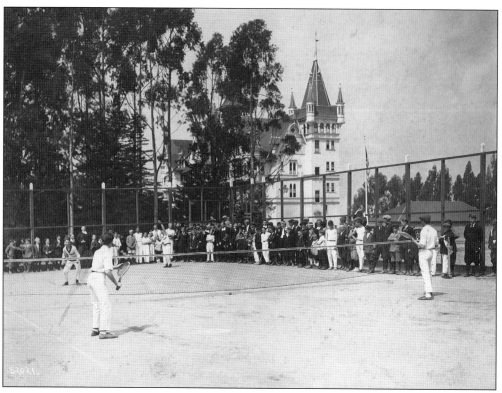

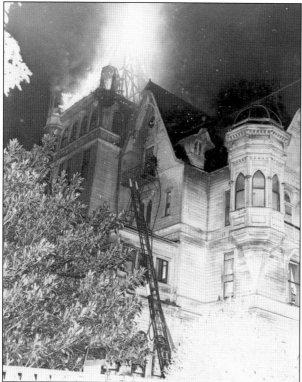

Students of St. Joseph's Academy gather for a tennis match. The former Peralta Park Hotel, seen in the background, housed the Academy and was later used as a residence hall. Saint Mary's College High School moved from Oakland to the site in 1927. (Courtesy of SFNO District Archives of the De La Salle Institute.)

In 1946, a fire broke out in the 80-foot-high south tower of the former Peralta Park Hotel, resulting in the top two floors being razed. The lower portion of the building was remodeled and continued to be used by the Christian Brothers until the building was demolished in 1959. (Courtesy of LyndsPhoto.com and SFNO District Archives of the De La Salle Institute.)

Three

THE WOMEN, THE GUNS, AND THE GARBAGE

Springtime in Albany not only marks the coming of summer, it also means a journey to the past. Spring is typically when children at Marin Elementary School transport themselves back in time, reenacting the struggle of the city's founders through a third-grade play.

"No Dumping! No Trash! No Dumping—Balderdash!" they shout as they tell the story that has been passed down in the city for decades. The play, part of a local history unit, is about an early 1900s conflict that developed between Berkeley and Albany when the former began dumping garbage in the neighborhood of the latter. In real life, the struggle culminated when a group of Albany women turned away Berkeley's garbage wagons at gunpoint, an event that led to the incorporation of Albany.

But the story is about more than trash dumping—it has just as much to do with a feared plague epidemic and possible statewide quarantine.

The year was 1908, and Berkeley had a significant problem—suddenly denied the use of its longtime garbage dump near the northwest edge of Alameda County, the city's garbage began piling up. At the same time, increasing incidents of bubonic plague in the Bay Area had caused many cities, including Berkeley, to undertake campaigns to eliminate excess trash and exterminate rats.

Although the number of cases of plague was relatively small, overall, health officials feared that without a vigorous, regional rat extermination campaign, a widespread epidemic could occur. A plague epidemic could be both a health threat and an economic threat. Some argued that the plague could lead to a statewide quarantine and a serious loss of trade, with no market for California fruits, vegetables, and other products. It was not an unfounded concern. In 1900, the first outbreak of plague in San Francisco caused Texas and at least two other states to declare a quarantine against California.

Meanwhile, the City of Berkeley, which had so far uncovered very few cases of plague, hesitated to devote significant resources to rat extermination and sanitation efforts. But with health officials pressuring, the city complied. Now, after plague concerns closed its long-term garbage dump, Berkeley entered a period the newspapers labeled the "Garbage Wars," when the city searched in vain for a new place to deposit its trash.

Berkeley first considered other dumping solutions before coming to Albany, which was then an unincorporated area known as the Ocean View district. For example, Berkeley had tentatively started dumping along its own bay shore, but angry West Berkeley residents organized vociferous protests. A plan to join with Oakland and dump barge-loads of garbage in the ocean was abandoned due to high costs. Berkeley also considered having local railroads transport the trash to marshes outside of the county, but residents of adjoining areas like Suisun were harshly opposed. Another potential solution was a garbage incinerator, but this was also controversial, expensive, and would take significantly more time.

Finally, Berkeley leased some land along the waterfront in Ocean View, paying the property owner, the San Francisco Chemical Company, a costly $250 per month. As the city began dumping its many accumulated loads of trash, the unhappy residents of Ocean View (a rural area of just 200–300 people) immediately organized to stop the deliveries. They went first to the Alameda County district attorney, who warned Berkeley that its garbage collectors (at this time called "scavengers") could be arrested if their dumping created a nuisance. But Berkeley was undaunted, believing Ocean View could not prove the dumping was a problem.

Frustrated with this response, a group of Ocean View residents, mostly women, decided to take action. After arming themselves with shotguns and other firearms, they gathered on Buchanan Street near the San Pablo Avenue intersection and formed a blockade in front of Berkeley's approaching garbage wagons. Their efforts were successful until a carload of Berkeley Chamber of Commerce officials met the group during a trip to inspect the new dump. The chamber officials summoned the county sheriff, who threatened to throw the Ocean View residents in jail if they continued to bear arms.

The event produced numerous, colorful newspaper headlines across the Bay Area: "Women with Guns Hold up Men – Sheriff to Rescue," "Angry Mob Holds Up Scavengers with Guns," "Armed Women Hold Garbage Men at Bay." Exemplifying the sensational style of journalism common at the time, some articles claimed a woman threw herself and her baby in front of the oncoming chamber auto (this coverage was later criticized by some of those involved).

The residents of Ocean View then tried once again to stop the garbage dumping through legal efforts. For example, they attempted to secure an injunction against Berkeley, with mixed results. Finally, in September 1908, they incorporated as the City of Ocean View and eventually solved the garbage problem by adopting an ordinance against outside trash dumping.

The plague scare eventually subsided in the Bay Area, and Berkeley developed other solutions for its refuse, including the use of a garbage incinerator. Ocean View changed its name to Albany, and along with other East Bay cities (post-earthquake), began to expand.

It is doubtful that the residents of 1908 Ocean View ever dreamed that more than 110 years later their struggle would be immortalized through a school play—but each spring as Albany schoolchildren take to the stage and recite their lines, the story will be remembered once again.

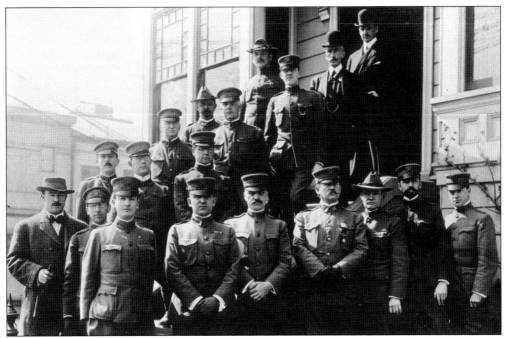

In 1908, the residents of Ocean View (soon to be renamed Albany) protested Berkeley dumping garbage in their vicinity, a concern heightened by a regional outbreak of plague. Sanitation and rat extermination campaigns were ongoing in the Bay Area. Here, a group of federal sanitary officers pose in front of the San Francisco Plague Suppressive Headquarters during the plague campaign in 1907–1908. (Courtesy of National Library of Medicine.)

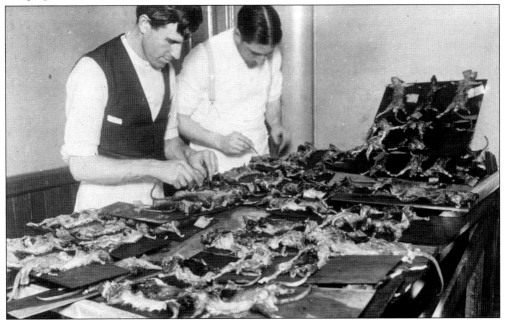

Two health workers dissect rats nailed to shingles at a San Francisco laboratory as part of the city's plague campaign. Similar efforts to identify the presence of plague were conducted in the East Bay. (Courtesy of National Library of Medicine.)

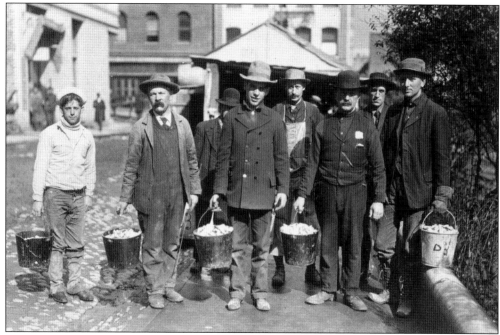

A group of San Francisco public health workers is pictured holding buckets of rat bait. The group was part of a large team combating plague in San Francisco. (Courtesy of National Library of Medicine.)

Rat extermination campaigns were underway in multiple Bay Area cities in 1907–1908. After being trapped, rats were typically tagged to identify where, when, and by whom they were collected. Health workers then dissected the rats to determine the presence of plague. (Courtesy of National Library of Medicine.)

OCEAN VIEW GIVES
LEGAL WARNING TO
THE GARBAGE MEN

Notice Served From District Attorney's Office
That Nuisance Must Be
Abated At Once

Many Bay Area residents were concerned about garbage dumps and the rats they attracted during the regional plague outbreaks of the early 1900s. In the spring of 1908, the people of Ocean View gave a legal warning to the Berkeley garbagemen dumping trash in their rural, unincorporated area, an action covered by a local Berkeley newspaper. (Courtesy of UC Berkeley.)

BARNETT PROTECTS THE
SCAVENGERS FROM HARM
AT HANDS OF MAD MOB

Armed Women of Ocean View Tract Show Signs of
Violence and Sheriff Warns them to Allow
Law to Take Its Course or go to Jail

Berkeley ignored the legal warning given by Ocean View, believing the trash deliveries could not be proved a "nuisance," and continued to dump its garbage. A group of Ocean View women then took up arms and formed a blockade on Buchanan Street to prevent the garbage wagons from reaching the dump site near the waterfront. A *Berkeley Gazette* headline described how Sheriff Barnett was called to the scene to protect the "scavengers" (garbagemen). (Courtesy of UC Berkeley.)

Armed Women Hold Garbage Men at Bay

IN BATTLE ARR
CITIZENS FIGH
BERKELEY
WASTE

**With Rifles, Pistols and St
Angry Ocean View Reside
Prevent Dumping.**

**WOMAN HURLS HERSEL
BEFORE HORSES' F**

**"I'll Die This Way Rather T
by Plague and Protect I
Children," She Cries.**

**POLICE RUSH TO SCENE
AND CROWD PROTE**

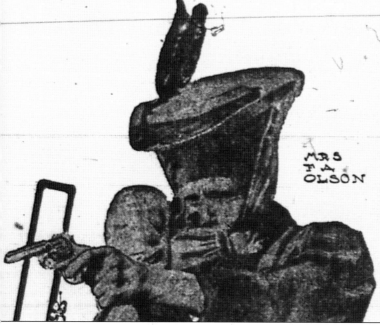

MRS
F A
OLSON

The garbage protest in Ocean View made headlines across the Bay Area. The *San Francisco Examiner* covered the event extensively on page one with multiple headlines and photographs. In the early 1900s, many newspapers routinely sensationalized the news in order to boost sales, and the event made perfect fodder for page one coverage. (Courtesy of UC Berkeley.)

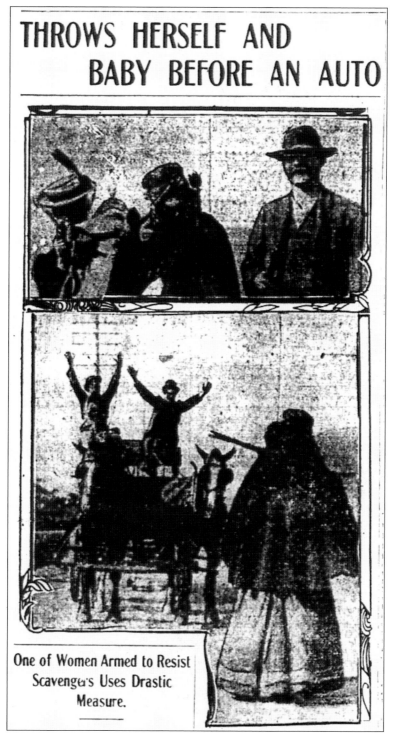

THROWS HERSELF AND
BABY BEFORE AN AUTO

One of Women Armed to Resist Scavengers Uses Drastic Measure.

The *San Francisco Chronicle's* headline claimed one of the Ocean View women at the protest threw herself and her baby in front of an oncoming automobile to prevent it from passing. The exaggerated coverage was later criticized by some of those involved. (Courtesy of UC Berkeley.)

Armed Women Chase Members of Berkeley Chamber of Commerce off the Garbage Dumps

The same day a group of women from Ocean View held back Berkeley's garbage wagons at gunpoint, a carload of Berkeley Chamber of Commerce officials, on their way to inspect the new dump site, met the armed group and were also turned away, as described in this headline from the *Oakland Enquirer*. The chamber officials then contacted the sheriff. (Courtesy of UC Berkeley.)

For many years, Albany schoolchildren have performed a play about the garbage incident as part of a third-grade study of local history. The play, which helped acquaint many Albany residents with the city's history, was written by now-retired teacher Karen Fox-Reynolds, who was honored with an award from the Albany Historical Society in 2013. Fox-Reynolds appears here with a group of Albany third graders on an Albany history walk in 2008. (Photograph by the author.)

Four

From a Challenging Beginning to the City of Today

"There was a Hot Time in New Ocean View. With red fire and a display of fireworks the birth of the new town of Ocean View was celebrated last night when the returns from the incorporation election were announced."

This headline and introduction from a 1908 *San Francisco Chronicle* article announced the beginning of Ocean View (the original name of Albany) with an upbeat, optimistic tone—but soon enough the article described, as many previous news stories had, the struggle that the small, rural area had undertaken to incorporate.

The first challenge to independence had come from Berkeley's school district, which newspapers said had unsuccessfully opposed Ocean View forming its own school district, thereby reducing Berkeley's student population. Soon after, Berkeley's longtime garbage dump closed and the city started discarding its trash in Ocean View, despite the protests of the area's residents. When Ocean View decided to incorporate to stop the dumping, the agitation continued.

Ocean View initially proposed that its city boundary extend farther east, including much of the remaining unincorporated land between the Berkeley city line (at that time roughly Codornices Creek) and the northern county line. However, this region included an area north of Berkeley in the neighborhood of today's Northbrae Community Church on The Alameda that was earmarked as a new site for the state capital. Many months earlier, a group of local developers and Berkeley business interests had solicited and received approval from state legislators for the capital move from Sacramento to Berkeley, but the proposal needed to be placed on the state ballot in November to be approved. Berkeley was opposed to Ocean View's suggested city boundaries, and quickly launched its own plan to annex the proposed capital site. News articles also suggested both cities were attracted to the potential tax revenue of the developing Northbrae area.

At the same time, a division was growing between residents of more industrial areas along the bay shore and those living to the east closer to the hills and university. West Berkeley (previously also called Ocean View before becoming part of Berkeley) was unhappy that the City of Berkeley had denied it liquor licenses. Berkeley had also attempted to establish a garbage dump in the city's west end, prior to dumping in the Ocean View district to the north. As a result of this and other tensions, a West Berkeley secession movement was launched. Ocean View had its own east/west divisions—the west side residents closer to San Pablo Avenue identified more with West Berkeley and wanted to incorporate as a separate city. The east side residents preferred their area to be annexed by Berkeley.

After some back-and-forth petition filing, the opposing groups met and worked out a plan: Ocean View would eliminate the capital/Northbrae area from its proposed city, leaving this for

Berkeley to annex, which it did in August 1908. Ocean View also cut out an area north of Solano Avenue near Neilson Street, where a workers' camp for the Spring Construction Company was located. Developer John Hopkins Spring was against Ocean View's incorporation, so in order to secure a majority vote at the polls, the area was removed from the proposed town—the result was the zigzag boundary that still exists there today.

Ocean View successfully incorporated—its boundaries now encompassing just 1.7 square miles—in September 1908. The proposed state capital move to Berkeley appeared on the November 1908 state ballot but was defeated 165,630 to 87,378—only a few Bay Area counties supported it. Today, the street names of California counties in the Northbrae neighborhood are visible reminders of the capital plan.

As the city of Ocean View embarked on its path of independence, new struggles arose. Financing the operation of the city in a sparsely populated rural area of 200–300 people was difficult. The city had elected a five-member board of trustees and established the positions of marshal, town clerk, and treasurer. Problems the board needed to address included muddy roads and a lack of streetlights. Ocean View also needed to pay the attorney hired to help stop Berkeley's garbage dumping. But when a bond election was held to raise funds, it was defeated by Ocean View voters.

It was at this time that gambling interests approached the town trustees to build a poolroom in Ocean View, which would generate license fees. In the early 1900s, "poolrooms" did not refer to billiards halls, but places where bets were placed on horse races, and they were controversial. As part of a nationwide anti-gambling movement, many cities and states (including New York) had outlawed them, and an anti-racetrack state law was being proposed in the California legislature. A group of Ocean View residents presented petitions opposing poolrooms to the board of trustees, and the decision to allow them split the board: two trustees were against poolrooms and three—who desired additional city revenue—were in favor of them.

Heightening the controversy was the opposition of the Alameda County deputy district attorney, who, according to news accounts, threatened to prosecute Ocean View if poolrooms were opened, but was unable to do so legally. In the end, Ocean View failed to pass an anti-poolroom ordinance, and two poolrooms opened in the new town, but were likely short-lived. The Walker-Otis Anti-Racetrack Gambling Bill was passed by the California legislature in early 1909, effectively ending thoroughbred racing and its associated poolrooms for years to come.

After a difficult start, the situation in Ocean View began to improve. By the time the city entered its second year, an ordinance against outside garbage dumping had been adopted and enforced; the first official public building, Albany School, had opened; and a volunteer fire department was being developed. The Oakland Gas Light and Heat Co. installed the first streetlights—five electric arc-lights along San Pablo Avenue costing $7.50 per month. The board of trustees made plans to "curb, grade, sewer and macadamize" San Pablo Avenue, and sidewalks and culverts were in the works.

City officials were also busy creating rules more suited to suburban than rural life. They introduced an ordinance regulating the discharge of firearms within city limits and set a speed limit of 10 miles per hour for the increasing number of automobiles. The board also moved to "restrict the keeping of milk cows to four head per single acre" and suggested licenses for dogs, "peddlers" and billboards.

In the fall of 1909, the city changed its name to Albany to honor its first mayor, Frank Roberts, who came from Albany, New York. Soon, the Southern Pacific railroad applied to establish an electric train along Main Street (Solano Avenue), which would improve transportation to Oakland and San Francisco. The operation and infrastructure of the city continued to improve as population and revenues increased.

After overcoming numerous obstacles to incorporation, it appeared Albany residents took nothing for granted. As each new milestone was reached—the opening of the first fire station, the first day of electric train service, the expansion of the school—Albany citizens gathered to mark the event and celebrate the evolution and continued independence of their city.

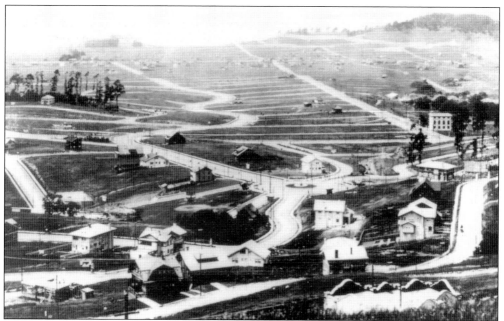

In the 1912 panoramic view above, the Berkeley Northbrae neighborhood is visible in the foreground, and much of Albany (mostly open fields) is in the background. The first proposed city boundaries for Albany, originally named Ocean View, extended farther east and included the Northbrae area. However, local developers and Berkeley business interests had earmarked then-unincorporated Northbrae for a proposed new state capital site and were opposed to Ocean View's plans. Some news headlines (*San Francisco Examiner*, right) suggested Ocean View was including Northbrae within its city to retaliate against Berkeley for dumping garbage in its district, but other articles pointed out both cities may have desired Northbrae's potential tax revenue. Ultimately, Ocean View agreed to cut the area from its proposed city, and Northbrae became part of Berkeley. (Above, courtesy of Friends of the Fountain and Walk; right, courtesy of UC Berkeley.)

OMIT CAPITOL SITE FROM APPLICATION

West Enders in Ocean View Make Sacrifice in Incorporation Effort.

FORGET THEIR "GRUDGE"

Had Included Tract in Retaliation for Garbage Dumping by Berkeley.

GAMBLERS RUN OCEAN VIEW

TRUSTEE SCHMIDT LEASES BUILDING TO POOL SELLERS

Another Racing Game Opens up, Gamesters Are Defiant, People Protest and District Attorney Will Investigate.

After incorporating, Ocean View found financing its city difficult and a bond issue to raise funds was rejected by voters. When gambling interests approached the city to set up controversial poolrooms where bets were placed on horse races, not all residents approved. But three of five city trustees desired the license fees from poolrooms, and when two opened, headlines ensued, such as this one from the *Oakland Tribune* written in the sensationalized style common at the time. (Berkeley trustee Schmidt was not a poolroom operator but leased a building to operators). A new state law soon prohibited poolrooms. (Courtesy of UC Berkeley.)

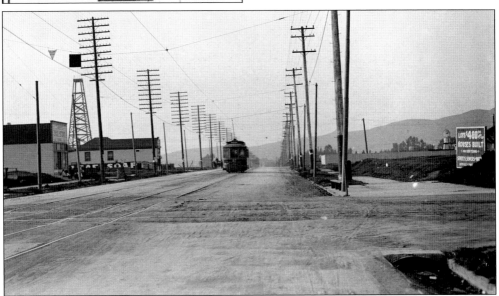

In this 1912 photograph looking north on San Pablo Avenue from Main Street (Solano Avenue), a sign to the right advertises lots for "$400 and up." To the left, a fake oil derrick—erected by developers to boost property sales—appears near two stores run by early Albany Italian families: the Latronico Shoe Store and the Sampietro Grocery. A Key System streetcar is visible at center. (Courtesy of Western Railway Museum Archives.)

This 1912 view from San Pablo Avenue looks west up Solano Avenue (then called Main Street). The fountain built by the Albany Improvement Club is on the corner near the Albany train station, which was constructed when the new Southern Pacific service began on Solano Avenue. Albany Hill, before development, appears to the right. (Courtesy of Western Railway Museum Archives.)

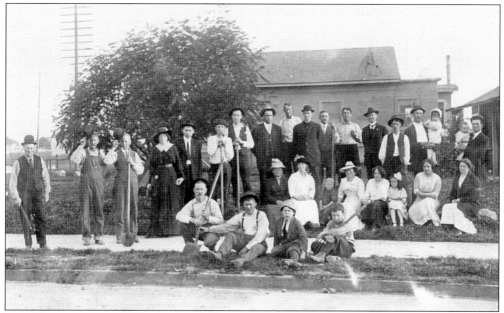

The Albany Improvement Club poses for a photograph while working to beautify Solano Avenue around 1912. Among those pictured are Albany's first mayor, Frank Roberts (standing fourth from right); the first town clerk, George Nickerson (standing eighth from right); and the first fire chief, Tom McCourtney (seated at far left). The organization was the first of many service groups that have supported Albany over the years. (Courtesy of Albany Library Historical Collection.)

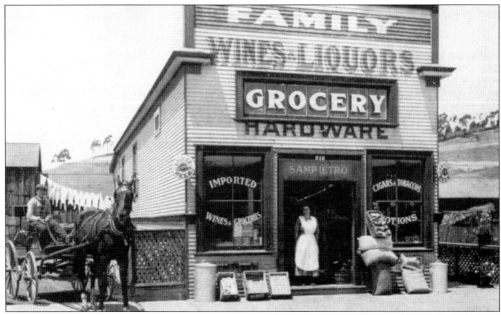

The Sampietro Grocery was an early store in Albany, located at 818 San Pablo Avenue (site of today's Albany Aquarium), when very few other buildings were there. The family's children, Nora (in the doorway) and Joe (in the wagon he used to deliver groceries) appear in this c. 1909 photograph. Descendants of the family still live in the Albany / El Cerrito area. (Courtesy of Albany Historical Society.)

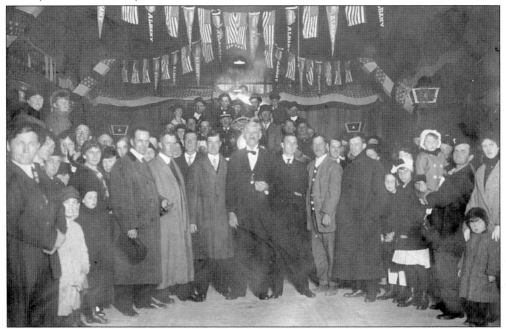

In 1915, Albany citizens gathered to celebrate the grand opening of the new firehouse on San Pablo Avenue at Washington Avenue. Mayor Daniels, Councilman Fred Brown, and Councilman Frank Roberts appear at center, while Fire Chief Tom McCourtney appears behind them in uniform seated on the fire truck. (Courtesy of Albany Library Historical Collection.)

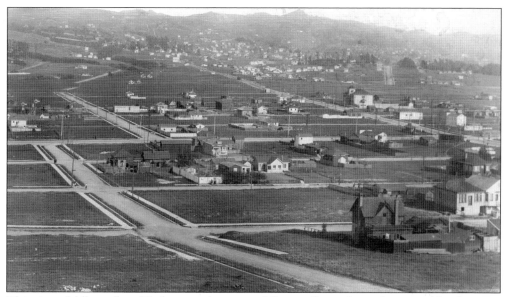

This view of Albany from Washington Avenue and Cerrito Street shows the state of development about 1912 when there were still many open fields. Washington Avenue runs through the image to the left, and Main Street (Solano Avenue) is to the right. (Courtesy of Albany Historical Society.)

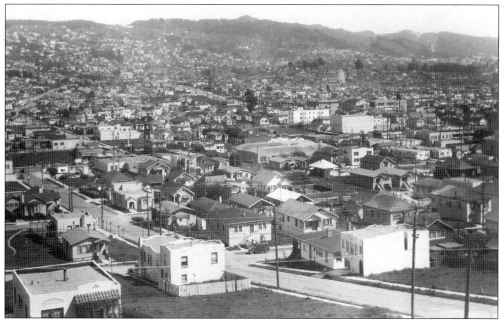

The view from Washington Avenue and Cerrito Street appears much different by 1932, when this photograph was taken. While there are still a few open lots, much of the city has been developed. (Courtesy of Albany Historical Society.)

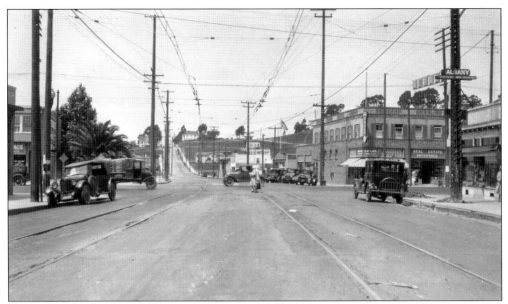

By the early 1920s, the area near Solano and San Pablo Avenues was becoming more developed. Commercial buildings, including the drug store on the northwest corner, had been built on all sides of the intersection, and an electric "Albany" sign (upper right) was hung across San Pablo Avenue. (Courtesy of Western Railway Museum Archives.)

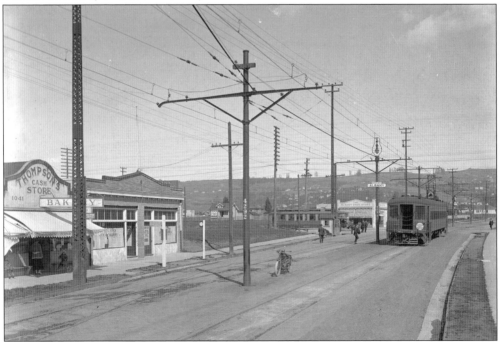

As Albany grew, so did many of its businesses and government organizations, but in 1915 Albany's new city hall and library were quite small, located in the building to the left next to Thompson's Store. The structure was on the north side of Solano Avenue between San Pablo Avenue and Adams Street. A Southern Pacific electric train can be seen at right. (Courtesy of Western Railway Museum Archives.)

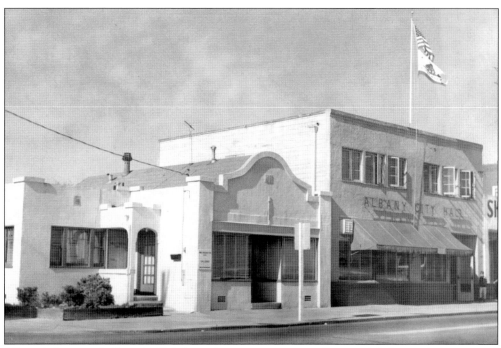

Albany's first city hall, at 1045 Solano Avenue, was eventually remodeled to include a second story, as seen in this c. 1950s photograph. The Albany Library was moved upstairs, creating more room for both organizations. (Courtesy of Albany Library Historical Collection.)

Albany's city hall opened at its current location, 1000 San Pablo Avenue, after a new civic center was constructed here in 1966. City leaders pictured in 2019 are, from left to right, (first row) Isabelle Leduc, assistant city manager; Nicole Almaguer, city manager; Rochelle Nason, mayor; and Peggy McQuaid, vice mayor; (second row) Michael Barnes, Nick Pilch, and Peter Maass, council members. (Photograph by the author.)

The Albany Library moved to this location at Talbot and Solano Avenues in 1952. The site was the former location of the first official Albany school building, later called Cornell School. (Courtesy of Albany Library Historical Collection.)

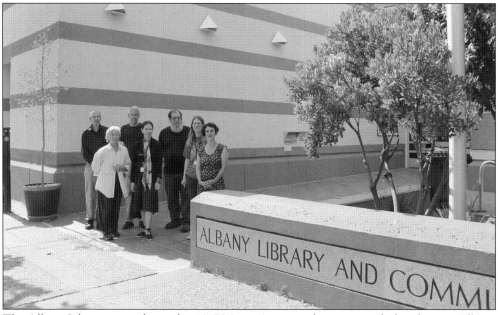

The Albany Library is now located at 1247 Marin Avenue, where it moved after the new Albany Library and Community Center was completed in 1994. The site was formerly the location of the Albany–Alta Bates Hospital. From left to right are library employees Gerry Wathen, Linda Leong, Eric Holland, Patty Azzarello, Steve Wasserman, Evelyn La Croix, and library manager Rachel Sher. (Photograph by the author.)

The Albany Fire Department opened its first official fire station in 1915 at the corner of San Pablo and Washington Avenues. Here, citizens pose with firemen alongside the city's first motorized fire truck. The vehicle was then state-of-the-art, with hammered copper and brass accessories. "She was really something to polish," recalled a fireman in 1948. Previously, Albany's volunteer fire department operated from a small building near Cornell and Solano Avenues where hand-pulled hose carts were stored. Since 1966, the fire department has been part of the civic center on San Pablo Avenue (below), which was upgraded in 2008–2010. Today, its services to the community include fire protection, emergency and disaster response, paramedic services, and more. Appearing here with department emergency vehicles are, from left to right, Lt. Erik Ortenblad, Lt. James Berry, and Firefighter Paul Nadarisay. (Right, courtesy of Albany Library Historical Collection; below, photograph by the author.)

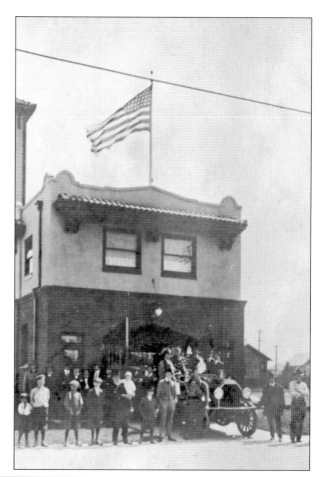

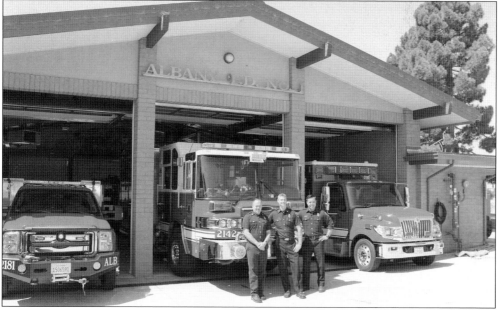

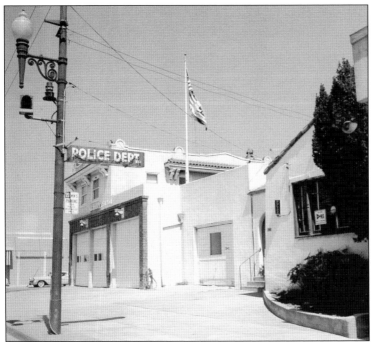

In Albany's early days, the police force consisted of a marshal and (sometimes) a deputy marshal. By 1927, the Albany Police Department was established with a police chief and three officers. In 1940, the department moved into a converted bungalow next to the fire station at San Pablo and Washington Avenues, pictured here in 1965. (Courtesy of Albany Library Historical Collection.)

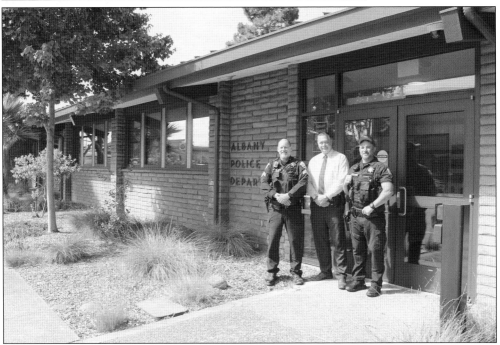

Like other city departments, the Albany Police Department moved to its current location at the civic center in 1966. Today, the department is comprised of a Patrol Division and a Support Service Division. Among its many community activities is the Albany Police Activities League, a youth program started in 1997. Appearing in this 2019 photograph are, from left to right, long-term department members Sgt. Thomas Dolter, Lt. Dave Bettencourt, and Officer Dave Lembi. (Photograph by the author.)

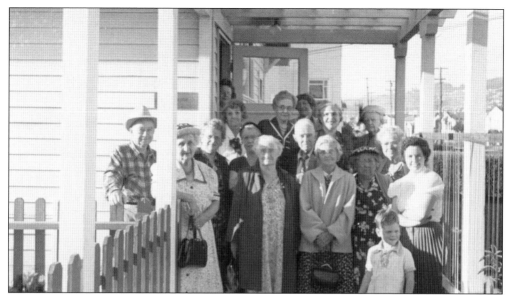

Members of the Albany Senior Citizens Club are seen here in the mid-1950s in front of their first meeting place, the Recreation Center at 846 Masonic Avenue. The group was formed with the help of the Albany Recreation Department, Soroptimists International of Albany, and the Albany Lions, Rotary, and Exchange Clubs. A new Senior Center was constructed at the same location in 1962 and later remodeled. (Courtesy of Albany Historical Society.)

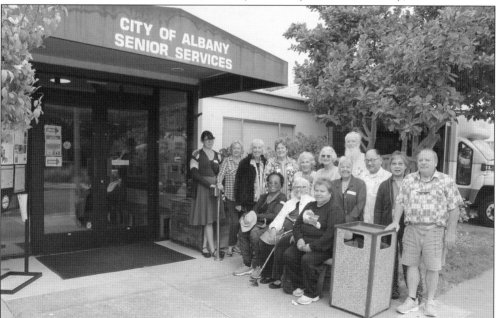

Today, the Senior Center, a division of the Albany Recreation and Community Services Department, is at the same location. Here, a group gathers before an outing in 2019. From left to right are (seated) Friends of Albany Seniors president Lorraine Davis, Margie Carr, and Dee Bonds; (standing) staff member Alana Rose, senior center supervisor Robin Mariona, Jackie Armstrong, Janet Chisholm, Zelda Holland, Margaret Doleman, Peter Doleman, Geri Handa, John Handa, Christine Yamashiro, and Richard Kekule. (Photograph by the author.)

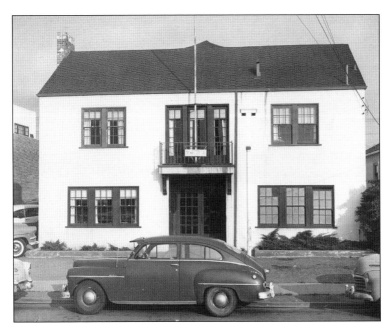

Founded in 1921, the Albany YMCA and Community Center operated as a branch of the Berkeley YMCA (established in 1903), later opening at 921 Kains Avenue in 1931. Seen here around the 1940s/1950s, the "Y" was used as a USO center during World War II, with activities for servicemen who were stationed nearby. (Courtesy of Albany Historical Society.)

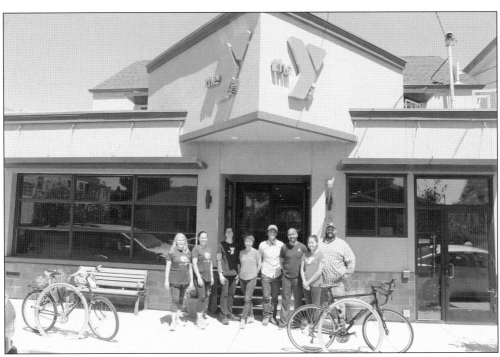

The Albany YMCA, still at the same location, has expanded both its services and building over the years and was most recently remodeled in 2017. Today, it is part of the YMCAs of the East Bay. Staff members appearing here in 2019 are, from left to right, Sharon Taylor, Dale Rowley, Cheri Stalmann, executive director Mary D'Elia, Rafael Rangell, David Meletiche, Nicole Natividad, and Sebastian de la Rosa. (Photograph by the author.)

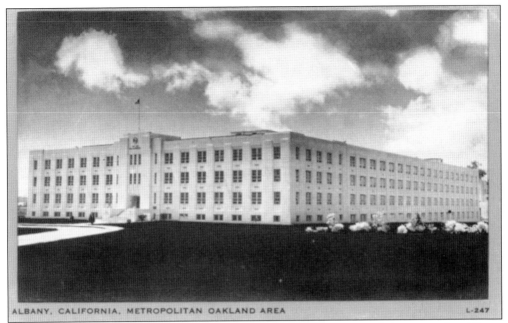

ALBANY, CALIFORNIA, METROPOLITAN OAKLAND AREA L-247

The Western Regional Research Center, pictured in this c. 1940s postcard, first opened in Albany in 1940 on a portion of the original Gill Tract. The center, part of the Agricultural Research Service, an agency of the US Department of Agriculture, became well known for frozen food research conducted in the late 1940s–1960s, among other research efforts. (Courtesy of Ed Clausen.)

The Western Regional Research Center (WRRC) has been operating for 80 years in Albany. More recent WRRC research includes helping food processors save water and property owners protect buildings from wildfire, as well as developing improved methods of botulism testing. (Courtesy of Agricultural Research Service-USDA.)

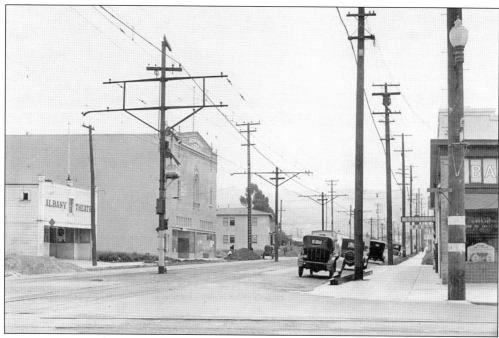

The Albany Theatre is one of the oldest businesses in Albany. The first theater opened in 1914 in the small building seen to the left in this 1920s photograph, which looks east on Solano Avenue from San Pablo Avenue. The theater's first showing was *The Perils of Pauline*, a melodrama film serial shown in weekly installments. At this time, the large building to the right, which would eventually become the theater, was an Italian social hall. (Courtesy of Albany Library Historical Collection.)

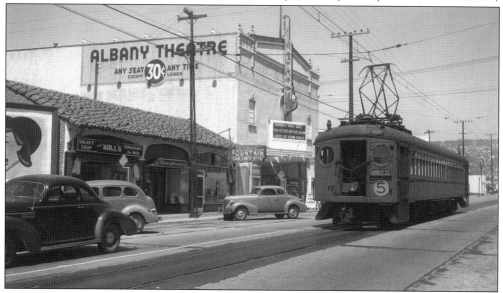

By 1935, the Albany Theatre had moved to 1115 Solano Avenue. Seen here in 1941 alongside the Southern Pacific Ninth Street train, the theater was showing two movies for 30¢: *Nice Girl?*, a musical starring Deanna Durbin, and *Footsteps in the Dark*, a mystery starring Errol Flynn. Also advertised was the now-famous Joe Louis vs. Billy Conn heavyweight championship fight held June 18, 1941, before a large crowd in New York City. (Courtesy of Western Railway Museum Archives.)

In the mid-1940s, the Albany Theatre was advertising its movies in the local *Albany Times* newspaper. This 1944 ad indicates *The Princess and the Pirate* starring Bob Hope was a major attraction, playing with the film noir release *Dark Mountain*, starring Robert Lowery and Ellen Drew. Also scheduled was *Heavenly Days*, a feature film starring Fibber McGee and Molly, the husband-and-wife comedy team from a popular long-running radio show. (Courtesy of Albany Historical Society.)

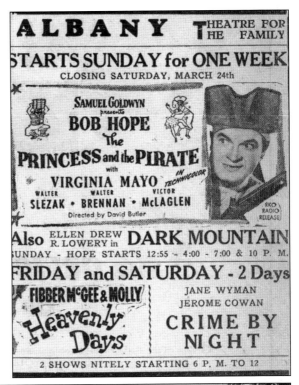

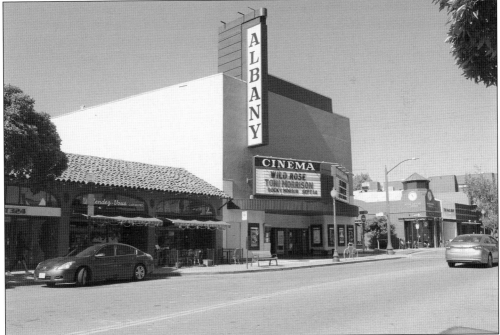

Today's theater, the Landmark Albany Twin, still operates in the same building on the corner of Solano and Kains Avenues. The theater's balcony was converted into a second auditorium in 1979, and Landmark took over the business in 1994. Shown here in 2019, the theater continues to be a centerpiece of downtown Albany. (Photograph by the author.)

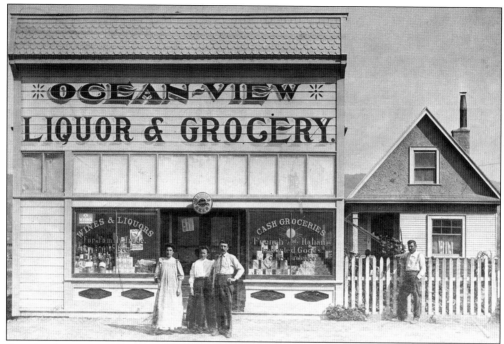

Another long-term Albany business was started by the Villa family. Here, Rosa and Peter Villa appear at center around 1908 with neighbors in front of their liquor and grocery store in the 900 block of San Pablo Avenue. In this photograph, the store bears the city's first name of Ocean View; the sign was soon changed to read "Albany Liquor & Grocery." (Courtesy of Albany Historical Society.)

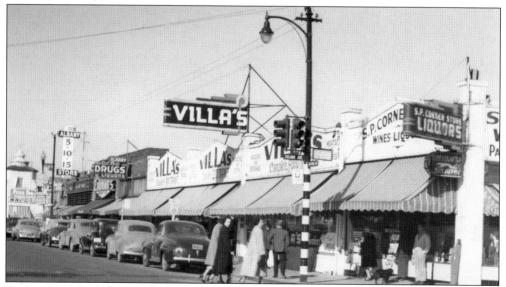

By the 1940s, the Villas' son Joe had expanded the family business into a chain of East Bay Villa's markets, including this grocery store on the east side of San Pablo Avenue near Solano Avenue. Next door is the S.P. Corner Store, which opened in 1923. For many years, it functioned as a waiting area for Southern Pacific electric trains, but by the 1940s it displayed a "Greyhound Bus Depot" sign. (Courtesy of Albany Historical Society.)

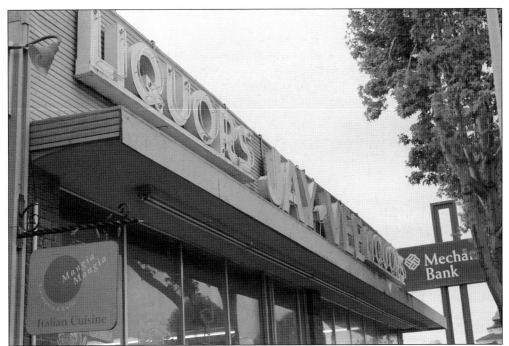

By the 1950s, Joe Villa had exited the grocery business and started a chain of liquor stores, known as Jay Vee Liquors. Still in operation throughout the East Bay today, the current Albany store is on the corner of San Pablo and Washington Avenues. "Customers tell me all the time about Joe Villa," said the store's current owner, Sangeeta Garcha. "Older people remember buying candy at his store when they were kids." Joe Villa was active in the Albany Rotary Club for many years. (Photograph by the author.)

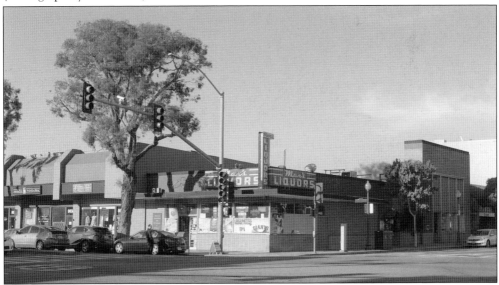

The first store on the northeast corner of San Pablo and Solano Avenues was the Albany Drug Store (see cover). This later became (Bittick's) S.P. Corner Store, which was later run by Max Etingoff & Sons. Eventually, it became known as Max's Liquors, which still operates under different ownership on the corner today. (Photograph by the author.)

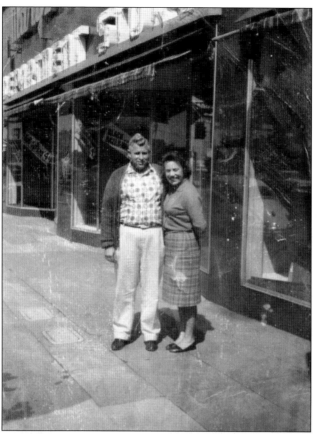

One of Albany's longest-running family businesses is Mary & Joe's Sporting Goods. Initially, the business was a grocery store on San Pablo Avenue started by Carlo Carlevaro, an Italian immigrant who arrived in Albany around 1920. He later moved to 913 San Pablo Avenue and established a department store (left). Carlo's daughter, the late Mary (Carlevaro) Neylon (left, at right), worked at the family store from age 12, eventually inheriting the business with her brother Joe. Mary and her husband, the late Pat Neylon (left) bought out Joe's share of the business, eventually shifting to sporting goods, and ran the store together for many years. Mary & Joe's Sporting Goods still operates today in the same building, run by Mary's daughter Kelly Neylon (below). (Left, courtesy of Kelly Neylon; below, photograph by the author.)

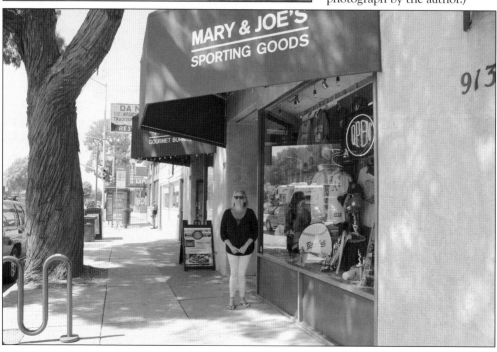

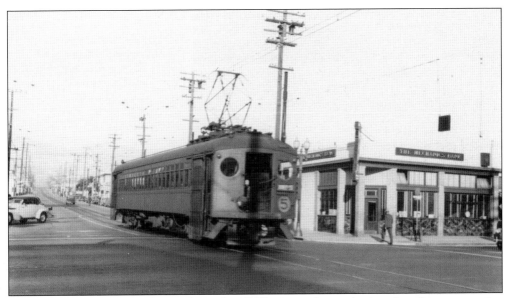

Mechanics Bank first opened in Richmond in 1905, serving the employees of two large companies: Standard Oil and the Santa Fe Railroad. The Albany branch opened in the mid-1930s at the southeast corner of Solano and San Pablo Avenues, shown here with a Southern Pacific "red train" in the early 1940s. (Courtesy of Bradas family, El Cerrito Historical Society Collection.)

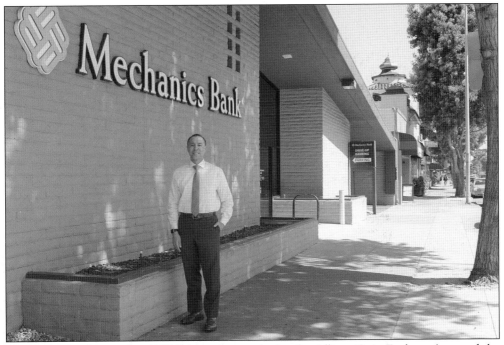

Mechanics Bank moved to 1107 Solano Avenue (today the Albany Coin Exchange) around the 1940s before moving to its present location at the corner of Washington and San Pablo Avenues (the former site of the fire station) in 1966. Albany branch manager Jason Alabanza, who has been at the bank since 2010, is pictured here in 2019. (Photograph by the author.)

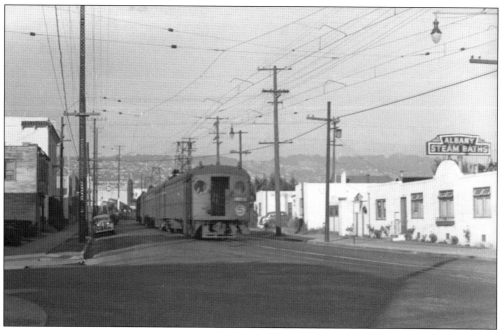

Albany Sauna first opened at 1002 Solano Avenue as the Albany Steam Baths in 1934. The sauna, pictured here next to a Southern Pacific electric train, was built by Finnish American Henry Walter Lundgren, who was active in the Finnish community of West Berkeley. (Courtesy of Western Railway Museum Archives.)

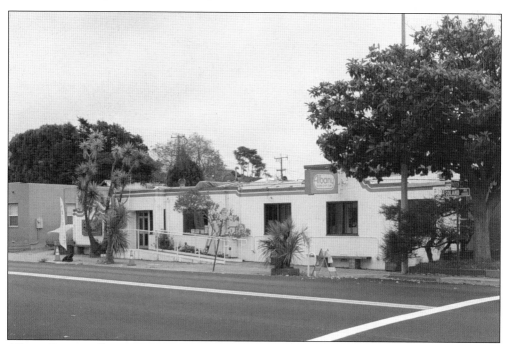

Albany Sauna, still operating as an authentic Finnish-style sauna, has been in business for more than 80 years. The business, which has had two subsequent owners since its founding, is one of the oldest Finnish-style saunas open to the public in North America. (Courtesy of Frederika Adam.)

The Hotsy Totsy Club has operated since the late 1930s at 601 San Pablo Avenue. Vic and Tiny were the proprietors of the bar in the 1940s when this ad was created. The bar still features shuffleboard and an antique Wurlitzer jukebox. (Courtesy of Michael Valladares.)

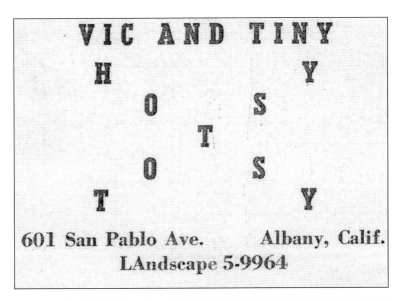

The Hotsy Totsy Club celebrated its 80th anniversary in 2019. Today, the bar attracts newcomers and old-timers alike, including Richie Cortese, a 1967 Albany High graduate from a longtime Albany family, who has patronized the bar for 50 years. Current owners Michael Valladares (who grew up in Albany) and Jessica Maria, shown here in 2019, bought the business in 2008 and renovated it, retaining its vintage style. (Photograph by the author.)

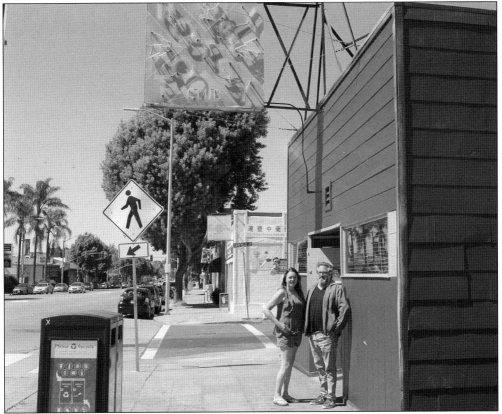

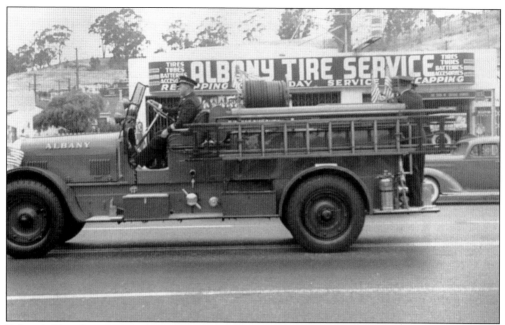

Fiderio's Tire Service, run by George Fiderio, opened at 742 San Pablo Avenue in 1940. The business, which later changed its name to Albany Tire Service (pictured here in a 1948 Fourth of July parade photo) specialized in tire "recapping" (retreading), popular in the 1940s. (Courtesy of Albany Library Historical Collection.)

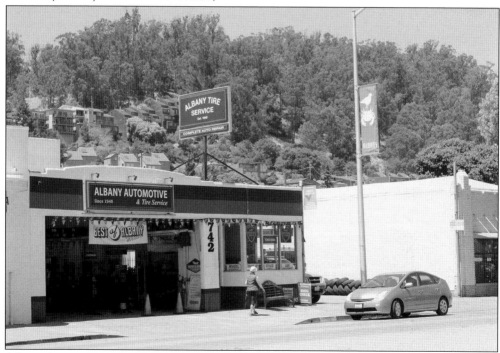

Albany Automotive & Tire Service, now providing complete automotive repair, still operates at 742 San Pablo Avenue. The business is now run by John Olson, who started as a mechanic in 1978 and became the owner in 1984. (Photograph by the author.)

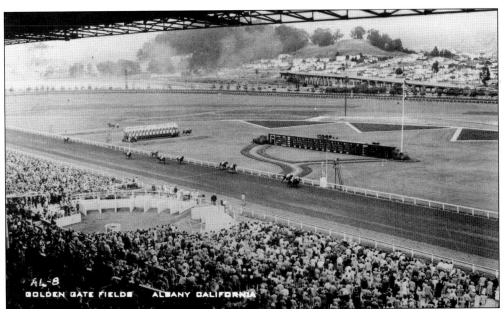

The Golden Gate Fields racetrack was built in 1939–1940 but was forced into bankruptcy shortly after it opened in 1941 after relentless rain destroyed the track. During World War II, the racetrack area became the Naval Landing Force Equipment Depot, where the US Navy maintained and stored landing craft used in the Pacific. The track, which reopened for racing in 1947, is featured on this postcard from the late 1940s. (Courtesy of Albany Historical Society.)

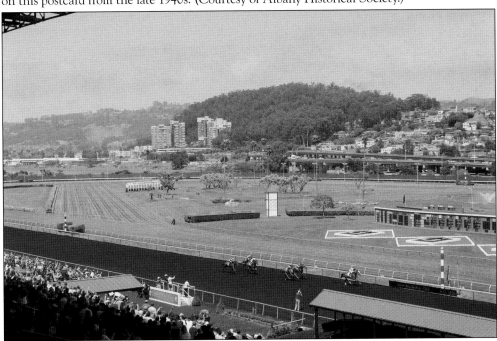

The view looking northeast from the Golden Gate Fields grandstand is similar today, but changes are visible in the background, including an expanded freeway and more development on Albany Hill. The business has operated for more than 70 years and is now the sole racetrack in the Bay Area. (Photograph by the author.)

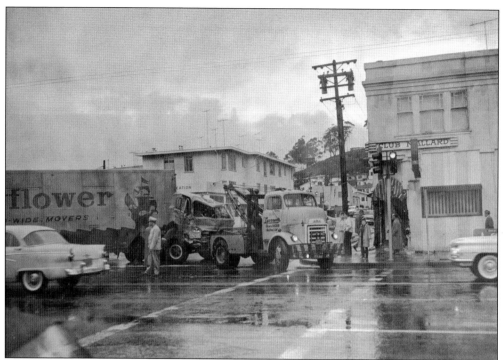

Club Mallard dates to the mid-1940s. The bar, at 752 San Pablo Avenue, was captured in the background of this c. 1960 photograph of an accident involving a moving van. (Courtesy of Albany Library Historical Collection.)

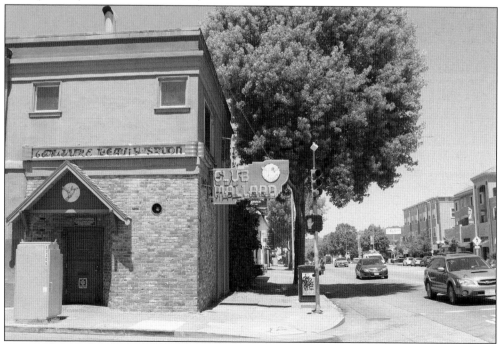

Club Mallard still operates at the same location. Today, regulars frequent the bar, which features pool tables and an outdoor patio and deck. (Photograph by the author.)

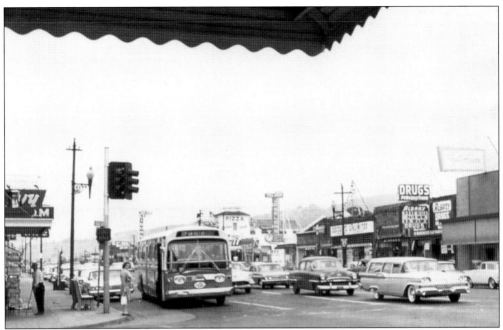

The Ivy Room, seen at far left in this c. 1960 view of San Pablo Avenue, has been operating at 860 San Pablo since the 1940s. The bar became well known in the 1990s when owner Dottie MacBeath's son Bill booked bands like Big Sandy & His Fly-Rite Boys and Chuck Prophet. (Courtesy of Albany Library Historical Collection.)

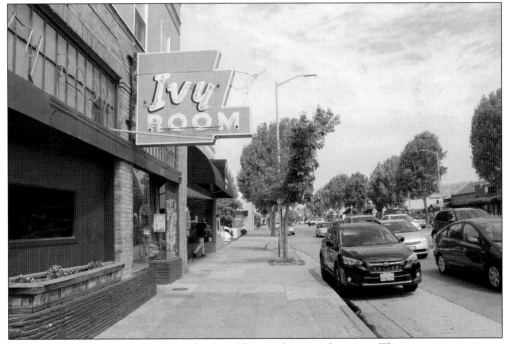

Today, the Ivy Room is still a neighborhood bar at the same location. The venue continues to feature live music—international, national and local acts—every week. The current owners, Summer Gerbing and Lani Torres, bought the business in 2015. (Photograph by the author.)

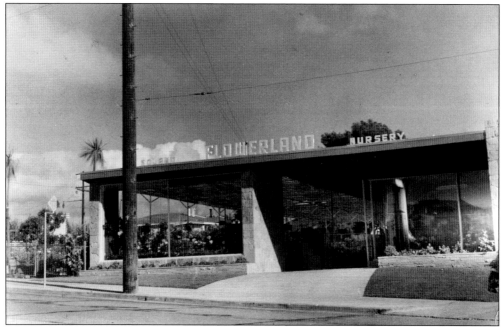

Flowerland was built by John Pleich, who opened the nursery at 1330 Solano Avenue in 1947. Pleich sold the business to Bob Willson, who was born and raised in Albany, and his wife, Frances, in 1976. Willson remembers shopping at Flowerland with his mom during his childhood. The Willsons ran Flowerland for 32 years. (Courtesy of Flowerland.)

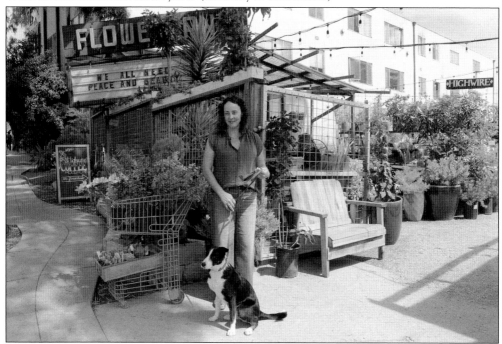

Carly Dennett, appearing here in 2019, took over Flowerland in 2008. Today, the nursery also includes a gift shop and outdoor coffeehouse that has become a local gathering place. The business celebrated its 70th anniversary in 2017. (Photograph by the author.)

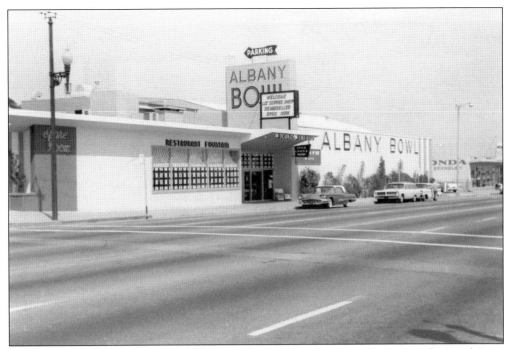

Albany Bowl opened at 540 San Pablo Avenue in 1949 and was run for 36 years by Frank Lacy and his son Bill Lacy. The bowling alley is seen here in the early 1960s. (Courtesy of Albany Historical Society.)

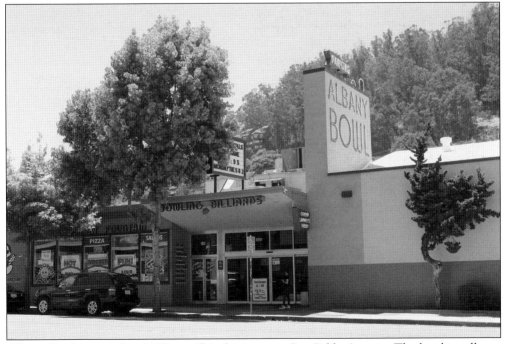

Albany Bowl, pictured in 2019, is still in business on San Pablo Avenue. The bowling alley—which today includes billiards, arcade games, a sports bar, and a restaurant—is currently run by John Tierney, who bought the business from the Lacy family in 1985. (Photograph by the author.)

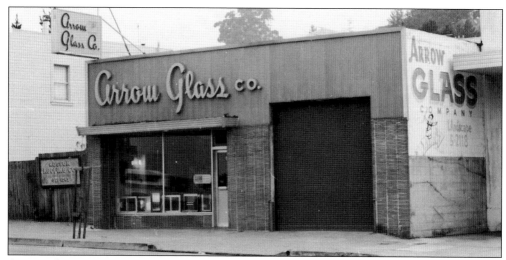

Arrow Glass, at 640 San Pablo Avenue, began in 1949, run by co-owners Charles Tscharner and Joseph Franco. Eventually, Tscharner's daughter Denise, who helped at the store as a child, bought out Franco and became partners in the business with her father. (Courtesy of Albany Library Historical Collection.)

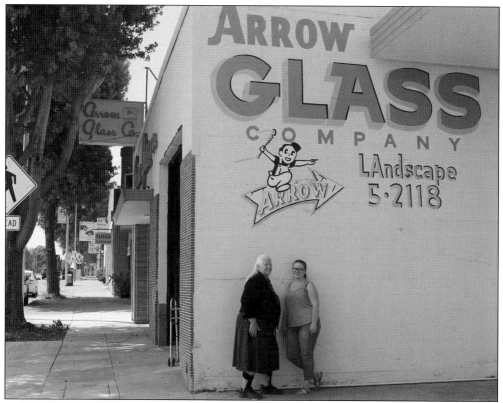

Today, Arrow Glass continues as a full-service glass company, run by the same family for over 70 years. Denise Grimshaw (left) took over the business from her father and now works with her daughter Ona Grimshaw (pictured) and her son Gabriel Grimshaw. Denise was selected to be the grand marshal of the Solano Stroll parade in 2016. (Photograph by the author.)

Five

THE TRAINS THAT
HELPED BUILD ALBANY

Fares from 5¢ to 10¢, 35-to-45-minute commutes to Oakland and San Francisco, and "noiseless, smokeless" all-electric trains boarded a few short blocks from home.

This was the typical commute for city workers who lived in Albany in the early part of the 20th century. By 1912 (four years after Albany's incorporation), three electric train/streetcar lines serviced the residents of what was still mostly a rural, open landscape: Key Route streetcars running along San Pablo Avenue, Southern Pacific trains on Solano Avenue, and Key Route streetcars boarded near the intersection of Santa Fe Avenue and (today's) Key Route Boulevard. These transportation systems were a lifeline for areas like Albany that were initially remote outliers to the urban centers of Oakland and San Francisco—a fact that did not escape the real estate developers of the day who laid out large housing tracts in Albany and financed the building of electric trains.

Following the 1906 San Francisco earthquake, many people moved to the East Bay seeking life away from crumbling, tall buildings. Albany was touted as "The Bungalow City." "The city dweller, educated to the apartment house plan of rooms on the one floor . . . [with] overhead or adjoining noises, also objectionable neighbors, readily realizes that a bungalow on the hillside or level plot of ground would be a luxury," stated a 1913 promotional brochure for Albany. Convenient railway transportation was a key factor that turned this vision into reality.

While electric railways greatly improved transportation efficiency for Albany residents, other trains existed previously in the area. The Northern Railway, a predecessor to the Southern Pacific, established a passenger and freight steam line in the late 1870s that ran along the bay shore. By the mid-1880s, the California & Nevada Railroad was running a narrow-gauge steam railroad through the area, extending from Emeryville to San Pablo and eventually as far as Orinda. In the pre-Albany area, the C&N purchased what would eventually become the Bay Area Rapid Transit (BART) right-of-way. Early timetables indicate a stop in the Albany/Berkeley area called Peralta Park (Maurice Curtis, the owner of the nearby Peralta Park Hotel, and other local businessmen helped promote the line for a time).

After suffering financial losses, the C&N passed into receivership, and in the early 1900s the Atchison, Topeka & Santa Fe Railroad bought the right-of-way between Richmond and Emeryville. Although the Santa Fe train did provide passenger service in the Albany area—early accounts tell of residents flagging the train for rides—the lack of an official station stop in the rural, unincorporated area meant those rides were unpredictable.

Better local transportation for Albany was provided by the Oakland Traction Company streetcars, part of the Key System, which began running along San Pablo Avenue around 1900. Albany riders could reach Emeryville, Oakland, Alameda, or San Leandro for a fare of 5¢, and with a transfer could connect with ferries to San Francisco. Beginning in 1905, riders going north

could reach Richmond by transferring at the county line to the Eastshore and Suburban Railway. Much of Albany's initial development occurred near San Pablo Avenue as a result.

In 1911, Southern Pacific was rapidly building electric train lines in the East Bay, attempting to catch up with its competitor, the Key System. Three of those lines, the Shattuck Avenue, California Street, and Ninth Street lines, began in late 1911 and early 1912 to service Berkeley and Albany. Station stops for what became known as the "Big Red Cars" or "Red Trains" existed along Solano Avenue at Contra Costa, Colusa ("Thousand Oaks"), Peralta, Ramona, Evelyn, and San Pablo Avenues ("Albany").

In Albany, the Red Train tracks turned south from Solano Avenue at Jackson Street and ran along Ninth Street (where Harrison Street was another nearby station stop) into Emeryville. From here, the trains continued to the SP's Oakland Pier, where riders boarded ferries to San Francisco. Without any required transfers, these SP interurban trains provided faster service for Albany's San Francisco commuters, who could reach the city in 35–45 minutes for 10–15¢ each way.

Another transportation option for residents of south Albany was the Key Route system, which could be accessed near the Berkeley city line at Santa Fe Avenue and (today's) Key Route Boulevard. Known as the Westbrae Dinky, this branch streetcar line connected riders to the Key System's Sacramento Street line, which traveled through Berkeley and Emeryville to the Key Route ferry pier in Oakland. The system's routes and pier resembled the shape of a key, resulting in the nickname "Key Route." Eventually, the company formally adopted the name Key System.

The Key System had intended to extend its line through Albany to Richmond along the right-of-way it owned—in Albany this was a block-wide strip of land west of Pomona Avenue—but for financial reasons the company chose to never carry out its plan. Eventually, homes were built in the portion of the strip south of Solano Avenue (part of a subdivision called Terminal Junction); north of Solano, the area became homes as well as the wide Key Route Boulevard.

In 1943, a new rail line began running through Albany, the Shipyard Railway. Built to transport workers to the Richmond Shipyards during World War II, the line stretched from Emeryville to Richmond. It picked up riders at numerous stops including Codornices Village (now University Village) in Albany/Berkeley, a government housing development for war industry workers. At one point, as many as 90 trains ran each weekday on Ninth Street through the village. The railway was dismantled in 1945 after the war.

By the early 1940s, autos and buses were becoming the dominant form of transportation. The Westbrae Dinky and the Southern Pacific Red Trains ceased operation in 1941, five years after the opening of the Bay Bridge. The Key System took over some of SP's lines and continued to operate for a few years—one of the closest trains to Albany was the Key's F line, which riders boarded from the top of Solano Avenue—and for a time Key System trains ran on the lower deck of the Bay Bridge. But by 1958, trans-bay train service ceased and the era of local electric interurban trains came to an end.

That same year, the Santa Fe discontinued its passenger runs on the former California & Nevada trackage between Richmond and Oakland. BART began building its tracks next to the Santa Fe line in the 1960s. For a time, Santa Fe freight cars and BART ran side by side, but by 1979 the Santa Fe ended service completely on this line.

Today's Albany commuters typically drive through heavy traffic or take BART from Berkeley or El Cerrito to reach Oakland, San Francisco, and beyond. Studies are showing major increases in Bay Area electric automobile sales—a growing trend that could reduce carbon emissions and pollution. Still, there have likely been many moments when residents wish they could walk a block or two from their homes and ride the neighborhood electric trains once again.

The California & Nevada Railroad was one of the earliest trains in the Albany area, beginning service in the mid-1880s along the right-of-way eventually acquired by BART. The train carried passengers as well as hay and other products, and ran from Emeryville to Orinda. The railroad's goal of reaching Nevada was never achieved. (Courtesy of Western Railway Museum Archives.)

Key System streetcars ran along San Pablo Avenue providing transportation to both Oakland and Richmond for the early residents of Albany. This 1912 view looks north on San Pablo from the Main Street (Solano Avenue) intersection, where there are still many open fields. (Courtesy of Western Railway Museum Archives.)

A Santa Fe train, running south alongside Masonic Avenue, approaches the crossing with Solano Avenue in 1913. The Masonic Tower, on the northeast corner of the intersection, was built about 1912 to help ensure safety where the Solano Avenue Southern Pacific electric trains crossed the Santa Fe tracks. (Courtesy of Albany Library Historical Collection.)

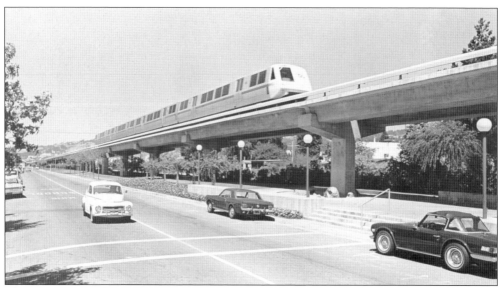

The same view as above was captured in the 1970s. In place of the Santa Fe train, a BART train is running along Masonic Avenue toward Solano. BART began operating in the early 1970s. (Courtesy of Albany Library Historical Collection.)

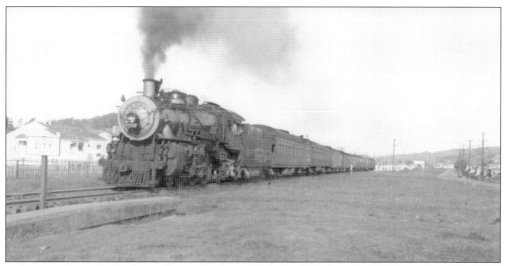

A Santa Fe train approaches Albany's southern border with Berkeley in 1938. The street to the far right is Pomona Avenue. (Courtesy of Whittaker family, El Cerrito Historical Society Collection.)

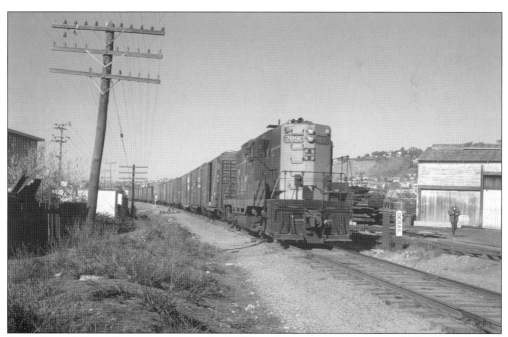

A westbound Santa Fe train is seen at the Hill Lumber Company in 1965. The lumber company operated for many years on Brighton Street at the current site of Albany Middle School. (Courtesy of Western Railway Museum Archives, El Cerrito Historical Society Collection.)

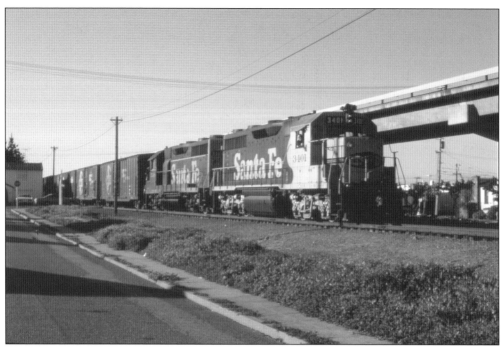

For a time, Santa Fe freight trains ran side by side with BART. This 1979 photograph shows a Santa Fe train at Portland Avenue. (Courtesy of Ron Hook, El Cerrito Historical Society Collection.)

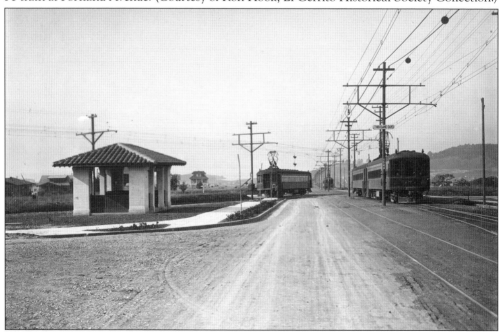

Southern Pacific commenced electric train service in Albany in late 1911. The large "Big Red Cars" approached Solano Avenue from the Northbrae Tunnel, from Colusa Avenue at the "Colusa Wye," and from Jackson Street, picking up passengers at various points along Solano. Three trains can be seen in this photograph from 1912, which looks west along Solano toward Albany from the Berkeley Thousand Oaks station, at left. (Courtesy of Western Railway Museum Archives.)

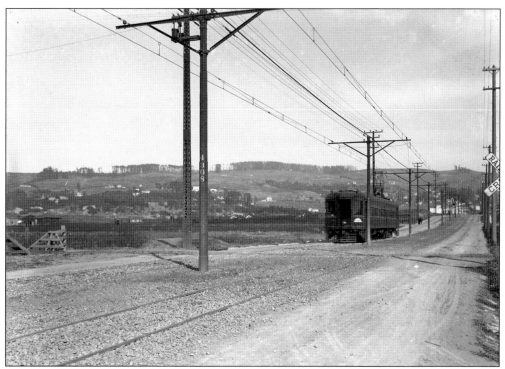

A westbound Southern Pacific Ninth Street train is seen on Solano Avenue in 1912 as it approaches Santa Fe Avenue. Solano is still a dirt road surrounded by open fields. Train service helped sell lots in the adjacent Albany and North Berkeley areas. (Courtesy of Western Railway Museum Archives.)

By the early 1940s when this photograph was taken, Solano Avenue was lined with businesses. This SP Red Train is pictured at Peralta Avenue. (Courtesy of Oakland History Room.)

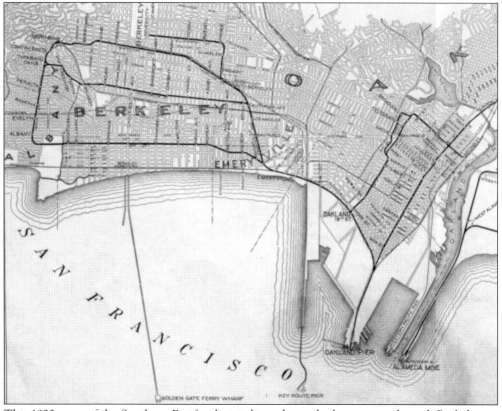

This 1920s map of the Southern Pacific electric lines shows the loop routes through Berkeley on Shattuck Avenue, California Street, and Ninth Street that led through Emeryville out to the Oakland Pier. The Key Route Pier is shown to the left of the Oakland Pier. At far left, train stops on Solano Avenue are highlighted, including four in Albany at Peralta, Evelyn, Ramona, and "Albany" (San Pablo Avenue). (Courtesy of Bay Area Rail Fan.)

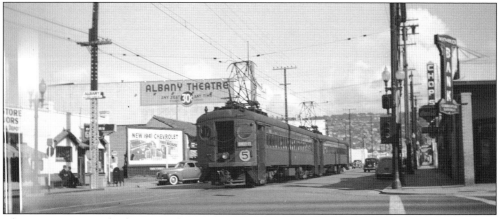

The year 1941 was the last year the SP Red Trains ran in Albany. This Ninth Street train at Solano and San Pablo Avenues is framed on the right by Mechanics Bank and on the left by the Albany Theatre and, prophetically, a large billboard for the 1941 Chevrolet. By this time, cars and buses were replacing the East Bay's extensive electric interurban railways. (Courtesy of Western Railway Museum Archives.)

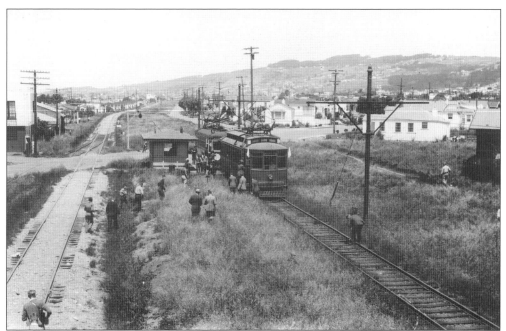

The c. 1940 view above shows streetcars at the Key System's Westbrae station near (today's) Key Route Boulevard and Santa Fe Avenue. From here, riders connected to the Sacramento Street line to Oakland and the Key's ferry pier. The view north shows the Key System's right-of-way between the Santa Fe tracks on the left and Pomona Avenue to the right. The company intended to extend its electric railway to Richmond, but never did for financial reasons. Although the area was subdivided in 1914, some of it was not developed until the 1930s–1940s. The houses to the far left were later demolished to make room for the BART tracks. Below, this c. 1917 subdivision map of south Albany's Fairmount Park, "The Ideal Bungalow Tract," shows the Key Route Reservation and the SP Solano Avenue line and touts the area's "unexcelled transportation." (Above, courtesy of the Oakland History Room; below, courtesy of Earth Sciences and Map Library, UC Berkeley.)

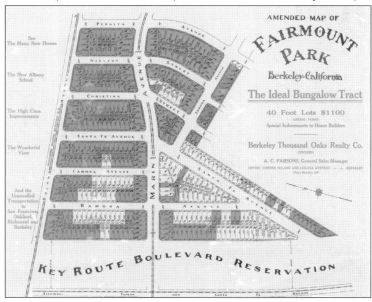

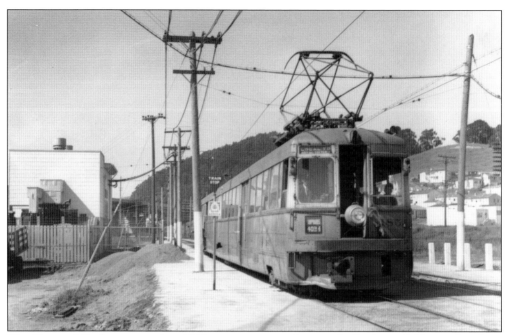

The Shipyard Railway opened in 1943 to transport workers to the Richmond Shipyards, where 747 ships were constructed during World War II. Here, a "Local to 40th and San Pablo" car is seen at a stop near Albany Hill in the early 1940s. The railway extended from Emeryville through Berkeley and Albany to Richmond and served thousands of riders daily. (Courtesy of Bradas family, El Cerrito Historical Society Collection.)

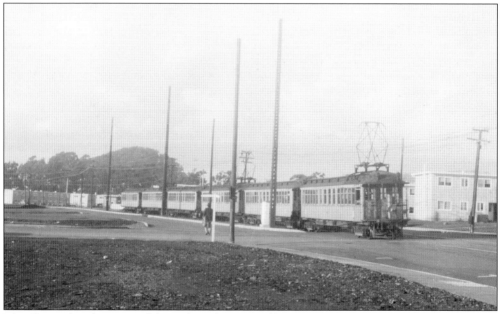

The Shipyard Railway passed through Codornices Village (seen in the background), a government housing project built in Albany and Berkeley for shipyard employees and other war industry workers in the early 1940s. The Albany portion of Codornices Village would later become University Village, which offers family housing for students of UC Berkeley. (Courtesy of Oakland History Room.)

Six

CHARLES MACGREGOR, THE "BUILDER OF ALBANY"

Most people who have lived in Albany have heard of Charles MacGregor: chances are, they either live(d) in or have visited one of the 1,500-plus homes he built throughout the city. Constructed mostly during the 1920s and 1930s, MacGregor homes are often touted by realtors as having attractive architectural features, and it is not uncommon for his name to appear in sales ads and flyers.

"MacGregor is famous for split-level living," said Diane Sindel-Deutsche, owner of Jeans Realty on Solano Avenue, a company that has operated in Albany for decades. For example, bedrooms are frequently located up a small flight of stairs and placed over a garage. While he built different styles, many of MacGregor's Albany homes were constructed in the Mediterranean- or Spanish-Revival style and feature appealing added extras. "MacGregor added quality with archways, large picture windows in the front living room, ornate tiled fireplaces, and built-ins," Sindel-Deutsche said. "His homes are known for their own style today—it's a part of history here."

His influence in Albany goes beyond homes, however. For years, the city celebrated MacGregor Day, an annual September event near his birthday. The first MacGregor Day in 1936 featured a parade, various games and contests, and a banquet, all in honor of the man local newspapers heralded as the "Builder of Albany." Subsequent MacGregor Days focused mostly on children—MacGregor would treat all Albany schoolchildren to free ice cream and a movie at the Albany Theatre. The event continued until his death in 1954.

What made a local builder so influential that a city holiday was named in his honor? One likely factor was that much of his work coincided with the Great Depression. During a time when economic vitality was collapsing, MacGregor was expanding the town of Albany and putting people to work. Family members and newspaper articles also describe his charitable giving during hard times—groceries, children's shoes, and medicine delivered anonymously to families in need, and an effort to stagger jobs to keep his workers employed through the rainy season. Two Albany schools have been named after MacGregor, the current MacGregor High School and a former primary school built in the late 1940s.

As well known as MacGregor is in Albany, he also built many structures elsewhere. Born in Nova Scotia, MacGregor came to the Bay Area as a young man around 1890. He first worked as a carpenter for others before striking out on his own. Some of his first structures were in Oakland, where he built homes as well as apartment buildings, including the elegant Madison Park Apartments at 100 Ninth Street. This 1908 structure, listed in the National Register of Historic Places, was once called the largest apartment building west of Chicago, and some claimed it was one of the first in the area with an elevator. A prolific builder, MacGregor also worked in San Francisco and built throughout the East Bay in Piedmont, Emeryville, Orinda, Alameda, Berkeley, El Cerrito, and Richmond.

But it was in Albany where his business really expanded. At first, people thought he was crazy when he began to buy Albany lots, said MacGregor's daughter, Charlotte MacGregor Boggs, in

a 1983 interview. At the time, Albany's open rural landscape was largely unappreciated—many considered the area the "end of the line," far removed from it all. Unlike other builders, MacGregor also bought numerous small lots in Albany. "There were so many 25-foot lots and it was hard to do anything with them," said Boggs, who once worked in her father's office. "He worked with a man who never finished his architecture course but he drew very good plans. He and my father worked together to make the plans for the little houses on the 25-foot lots."

By the mid-1930s, MacGregor had built several hundred homes in Albany and decided to move his office here from Oakland. He built the commercial building that still stands today at the corner of Carmel and Solano Avenues (which recently became eligible for the National Register of Historic Places) and moved his office into a portion of it in 1936. MacGregor continued his construction in Albany into the 1940s.

Over the years, he acquired the nickname "One-Nail MacGregor." Several stories evolved about the origin of the name. One suggested MacGregor himself put one nail somewhere in every one of the homes his company built. Another story was that he asked job applicants to demonstrate their skills by taking a hammer and driving one nail.

Not everyone liked MacGregor, and some of the "one-nail" stories related to quality. Some said MacGregor was known to be thrifty, especially during the Depression, and found a way to install a piece of lumber using one less nail. Those who disliked him stressed that the moniker referred to inferior building practices. "His competition said he wasn't putting in as many nails as he should," said the late Ingraham "Bud" Read Jr., MacGregor's grandson, in a 2007 interview. But Read and others also heard people praise the quality of his homes, saying he put in one nail *more* than other builders.

While not everyone agrees on his building methods, few dispute that MacGregor left his mark in Albany.

"I remember going out with [my father] once," Boggs said of a trip to a viewpoint near Albany. "He had this little car and he took me out and here was this great expanse of land. He looked at it and said, 'I'm going to start building out here. . . . You know, I think someday this will be a good town—a family town.' "

Charles MacGregor moved from Nova Scotia to the Bay Area around 1890, first working as a carpenter for others and then building his own structures. By the 1920s, he was building in Albany, where he eventually constructed more than 1,500 homes. Known as "One-Nail MacGregor," he is pictured here in his later years. (Courtesy of Albany Historical Society.)

C. M. MacGREGOR 6500 Homes Constructed in Half Century by East Bay Builder

"MacGregor Built" homes pictured here consist of five rooms, each selling for $3,564 under FHA terms. They each include two bedrooms, living room, dining room, large kitchen, garage, tile sink and drainboard, tile bathroom floor, hardwood floors, cove-edge inlaid linoleum, electric heater in bathroom and Andrews heater in living room.

C. M. MacGregor, who has been building homes in the East Bay area for nearly fifty years, has been building homes in Richmond since 1938. During that time nearly 100 fine modern homes have been built and sold to residents of the city.

In the half-century history of Mr. MacGregor's career, he has built approximately 6,500 homes. Most of the homes have been of the five and six room type, the plans for which have always kept abreast of modern improvements.

Even during the years of the depression he continued building new homes, keeping his staff of skilled workmen busy. Many of these workmen have been working with him for more than 25 years.

Most of the homes built by Mr. MacGregor have been constructed in Oakland, Berkeley, Piedmont and Albany, Alameda county. Albany is a city which is largely "MacGregor Built."

A MacGregor home bears the marks of quality materials, skilled workmanship, beauty, comfort and modern convenience and style. Further than that, Mr. MacGregor has combined real quality and low price. He has worked consistently in keeping with the policy that no matter how small the down payment the buyer has a real equity in his home.

C. M. MacGREGOR
1391 Solano Avenue ALBANY Thornwald 6879

This ad for C.M. MacGregor, which ran in the *Richmond Independent* newspaper in 1940, indicates that the builder had constructed 6,500 homes over the previous 50 years in the East Bay. The houses pictured are typical of the many five- or six-room homes he built during his career. (Courtesy of Chris Treadway.)

MacGregor's early buildings included the sophisticated Madison Park Apartments, a 1908 structure still in use at 100 Ninth Street in Oakland. It was once called the largest apartment building west of Chicago. (Photograph by the author.)

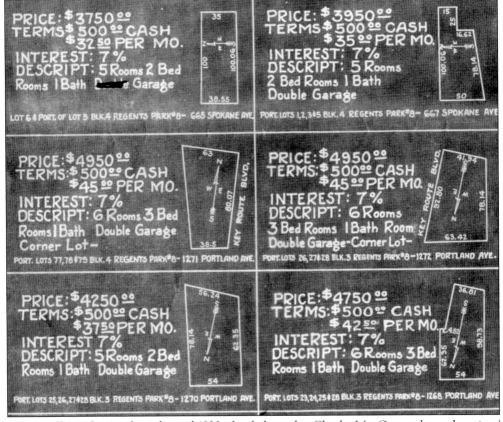

PRICE: $3750⁰⁰
TERMS $500⁰⁰ CASH
$32⁵⁰ PER MO.
INTEREST: 7%
DESCRIPT: 5 Rooms 2 Bed
Rooms 1 Bath [] Garage

LOT 6 & PORT. OF LOT 5 BLK.4 REGENTS PARK #8— 665 SPOKANE AVE.

PRICE: $3950⁰⁰
TERMS $500⁰⁰ CASH
$35⁰⁰ PER MO.
INTEREST: 7%
DESCRIPT: 5 Rooms
2 Bed Rooms 1 Bath
Double Garage

PORT. LOTS 1,2,3&5 BLK. 4 REGENTS PARK #8— 667 SPOKANE AVE.

PRICE: $4950⁰⁰
TERMS: $500⁰⁰ CASH
$45⁰⁰ PER MO.
INTEREST: 7%
DESCRIPT: 6 Rooms 3 Bed
Rooms 1 Bath Double Garage
Corner Lot—

PORT. LOTS 77,78 &79 BLK. 4 REGENTS PARK #8— 1271 PORTLAND AVE.

PRICE: $4950⁰⁰
TERMS: $500⁰⁰ CASH
$45⁰⁰ PER MO.
INTEREST: 7%
DESCRIPT: 6 Rooms
3 Bed Rooms 1 Bath Room
Double Garage—Corner Lot—

PORT. LOTS 26, 27&28 BLK. 3 REGENTS PARK #8—1272 PORTLAND AVE.

PRICE: $4250⁰⁰
TERMS: $500⁰⁰ CASH
$37⁵⁰ PER MO.
INTEREST 7%
DESCRIPT: 5 Rooms 2 Bed
Rooms 1 Bath Double Garage

PORT. LOTS 25,26,27&28 BLK. 3 REGENTS PARK #8— 1270 PORTLAND AVE.

PRICE: $4750⁰⁰
TERMS: $500⁰⁰ CASH
$42⁵⁰ PER MO.
INTEREST: 7%
DESCRIPT: 6 Rooms 3 Bed
Rooms 1 Bath Double Garage

PORT. LOTS 23,24,25 &28 BLK.3 REGENTS PARK #8— 1268 PORTLAND AVE.

A sheet of home listings from the mid-1930s that belonged to Charles MacGregor shows the prices/ terms for new Albany homes he built on Spokane and Portland Avenues. The homes were built during the Great Depression, and prices ranged from $3,750 to $4,950. Buyers were required to put $500 down, then make monthly payments of $32–$45. (Courtesy of Albany Historical Society.)

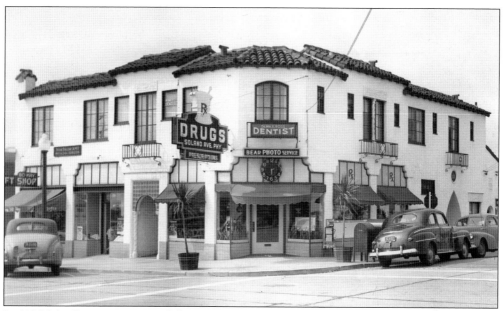

In 1936, MacGregor constructed this commercial building, which still stands today at the corner of Carmel and Solano Avenues, and moved his office here from Oakland. For many years, 1391 Solano Avenue was the headquarters of MacGregor Homes. The first MacGregor Day was held in Albany on September 12, 1936, and the event was celebrated annually for nearly two decades. Below, an *Albany Times* article describes the first celebration, which included a parade, athletic contests, and an evening banquet/dance at the Veterans Memorial Hall attended by 300 people. Albany mayor O.C. Yenne named MacGregor "Mayor for the Day" and MacGregor treated children to a free movie with ice cream at the Albany Theatre. The following year, the *Albany Times* reported that more than 1,000 children showed up for the free movies, and this became a popular annual event. (Both, courtesy of Albany Historical Society.)

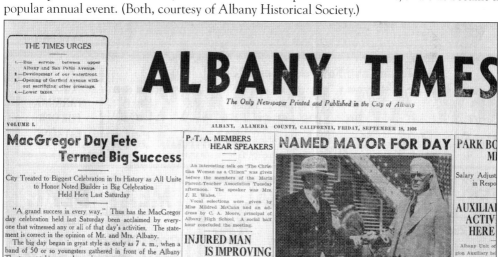

MacGregor School, named after Charles MacGregor, was a primary school that opened at the corner of San Gabriel and Brighton Avenues in the late 1940s. The school site, above, was later used for various purposes, including the Albany Adult School and MacGregor High School before being torn down to make way for the new Albany Middle School Annex in 2019. Below, a late 1940s photograph shows the MacGregor School basketball courts and playground. (Both, courtesy of Albany Historical Society.)

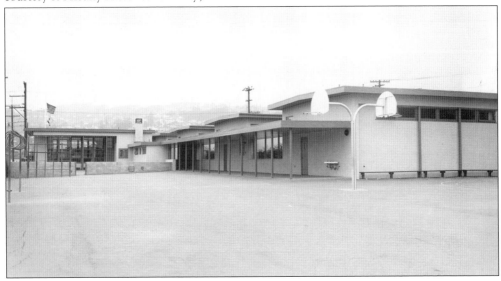

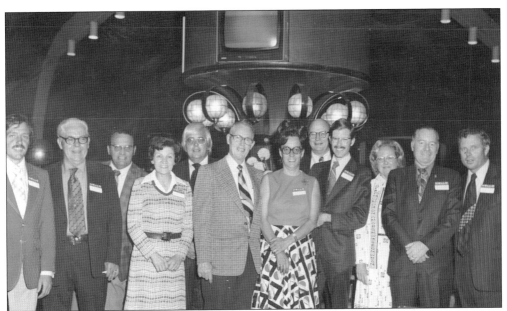

MacGregor's grandson, the late Ingraham "Bud" Read Jr., once ran the property management portion of MacGregor's business and was an active Albany businessman. He appears here with a group of Albany city officials and Chamber of Commerce hosts at the 1974 Alameda County Mayors Conference at Golden Gate Fields. From left to right are Michael Gleason, George Hein, City Council; Bud Rooney, Park & Recreation Department; Betty DeLucci, treasurer; Ingraham Read, Hal Denham, Chamber of Commerce; Pat Dempster, city clerk; James Turner, administrative officer; Pat Griffin, City Council; Bette Rhodes, finance officer; Hubert F. Call, and Dick Clark, City Council. Below is a 1938 house in central Albany that realtors termed a "classic MacGregor." (Above, courtesy of Albany Library Historical Collection; below, photograph by the author.)

Some Albany neighborhoods are dominated by MacGregor homes, including the San Gabriel Triangle, pictured here. These MacGregor houses were built in the 1930s and feature the Mediterranean style MacGregor is known for. (Photograph by the author.)

This 1930s home in eastern Albany is one of many MacGregor built on small 25-foot lots. The home was remodeled and expanded in 2018 by Jerri Holan & Associates, Architects, and preserves original MacGregor elements including Spanish Mission roof tile, handmade ceramic tiles, arches, and stucco relief. (Courtesy of Jerri Holan.)

Seven

ALBANY SCHOOLS: A LOOK BACK

The entire town turned out on the evening of December 12, 1908. The grand ball and celebration had been planned for some time, as construction of the new school along Main Street neared completion. Several committees were formed to organize the ball: Mayor Frank J. Roberts was part of the reception committee, and Fire Chief Tom McCourtney was helping with floor management. Mrs. Tevlin and Mr. and Mrs. Nielson (now familiar street names) were among the many organizers.

The event was important to the citizens of the new city of Ocean View (soon to be renamed Albany). The new school building not only provided adequate education facilities for their children, it served as an anchor for the town, a symbol of its legitimacy.

Albany School, located on Main Street (Solano Avenue) between Cornell and Talbot Avenues, was the first official public building in Ocean View, a small rural area that had incorporated just three months earlier. According to the local newspaper, the large two-story structure was designed by "well-known San Francisco architect J. W. Forsyth," and featured eight classrooms, steam heat, electric lights, internal telephones, and a large second-floor auditorium. The school, which stood out among the open fields that surrounded it, was the pride of the community, and for many years it was the location of civic and community meetings.

Education was important to Albany residents from the start. The school district was established even before the incorporation of the city, and children were educated in a converted barn until the new schoolhouse was built via a $22,000 bond issue. According to news accounts, Berkeley had initially been against the establishment of the Ocean View School District, opposed to losing an estimated 100 children from its own school system. But the residents of Ocean View prevailed, and the new district began in February 1908.

As the population of the East Bay expanded, so did Albany, and by 1916 Albany School was crowded. A $42,286 bond issue was passed, and in 1917 a second grammar school, Marin School, was built at the corner of Marin and Santa Fe Avenues.

By the 1920s, the school district was well established, but Albany still lacked a high school, and older students typically went to other nearby cities to complete their secondary education. The school board decided to relieve overcrowding at the elementary schools by establishing Herbert Hoover Junior High School at the corner of Pomona Avenue and Thousand Oaks Boulevard. Seventh and eighth grades were transferred there in 1928, and ninth grade added the next year. Some residents began to push for a full Albany high school, but the situation soon became a major controversy.

Many citizens, mostly those living on the east side of town, wanted their children to automatically attend Berkeley High School. Known as the Albany Taxpayers League, they advocated that the city of Albany merge with Berkeley to facilitate the change. But other residents—generally those living on the west side of town—as well as Albany officials and business owners, preferred that Albany build its own high school.

Many heated meetings were held, including one where members of the Albany Taxpayers League walked out to find the tires of their cars were flat, a deed presumably carried out by the west end "flatlanders." Three elections were held during this time to vote on the issue, and while the results were sometimes close, each time, consolidation with Berkeley was rejected. By the mid-1930s, Albany began building its own high school using a combination of local tax revenue and state and federal funds.

Between 1933 and 1947, the number of students attending Albany schools jumped from approximately 1,570 to 3,340. In 1944, another grammar school was added. Codornices Elementary School was built by the Federal Housing Authority for children of the war workers living in Codornices Village (later University Village). The school was leased to the Albany school district and quickly became the largest of the three elementary schools.

By 1947, there were over 800 pupils at each of the city's three elementary schools (kindergarten through seventh grade), approximately 900 at the high school, and another 125 people enrolled in the district's adult school. With the funding available at the time, most of the schools had a cafeteria, a nurse, and an after-school supervised recreation program, the latter operated jointly by the school district and the city recreation department.

Another expansion of the school system occurred in the late 1940s when two bond issues were passed to reduce overcrowding. Two new primary schools were built for kindergarten through third grade: C.M. MacGregor School at San Gabriel and Brighton Avenues, and Vista School near Jackson and Castro Streets. At the same time, the original Albany schoolhouse (Cornell School) along Solano Avenue was torn down and a more modern structure erected just to the south. The original swimming pool at Albany High School was soon constructed and Cougar Field purchased and developed.

By the early 1970s, another school upgrade became necessary when the state declared Marin School and portions of Cornell School unsafe for earthquakes. After much community involvement, a $1.62 million bond measure was passed and a state loan secured to rebuild Marin School and part of Cornell, as well as construct a new middle school at Jackson and Buchanan Streets. The latter became Ocean View Elementary School after a new middle school was opened at 1259 Brighton Street (the former site of Hill Lumber Company) in 1999. The late 1990s was also when the old Albany High School and gymnasium were torn down and replaced with a new, more earthquake-safe structure, which opened in 2001.

As of 2018, there were more than 3,600 students attending school in Albany. Another school upgrade is underway that will expand Albany High School, rebuild Marin and Ocean View Elementary Schools, and replace the old MacGregor School with the new Albany Middle School Annex.

The Albany school system, now more than 110 years old, has grown and changed with the city. Like the city itself, the district has not operated without controversy, yet its schools continue to receive high rankings and Albany continues to have a reputation for quality public education. Education remains a top priority for many Albany residents, just as it was in 1908 for the group of rural landowners who pushed to start their first school in a barn.

The first Albany school was established in 1908 in this refurbished barn near Brighton and San Pablo Avenues. The structure, donated by school trustee Chris Miller, was also used for early civic meetings. (Courtesy of Albany Library Historical Collection.)

The city's first schoolchildren pose in front of Miller's barn in 1908. Their teacher, in the back, was B.A. Collier. (Courtesy of Albany Library Historical Collection.)

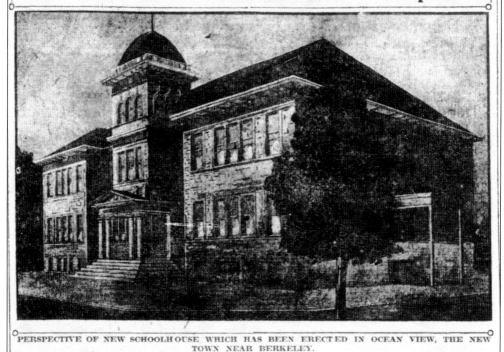

New Ocean View Schoolhouse Is Completed

PERSPECTIVE OF NEW SCHOOLHOUSE WHICH HAS BEEN ERECTED IN OCEAN VIEW, THE NEW TOWN NEAR BERKELEY.

The *Oakland Tribune* announced the completion of the new schoolhouse in Ocean View (soon to be renamed Albany) in December 1908. The two-story structure, the city's first official public building, was erected along Main Street (Solano Avenue) between Cornell and Talbot Avenues. Below, families walk along Cornell Avenue to the school around 1912. (Above, courtesy of UC Berkeley; below, courtesy of Albany Library Historical Collection.)

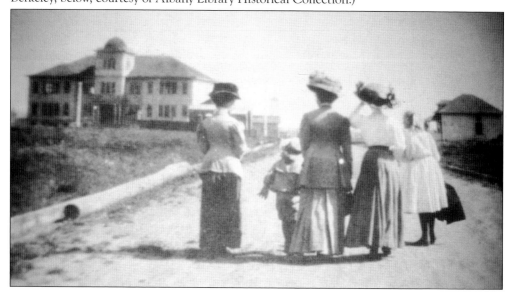

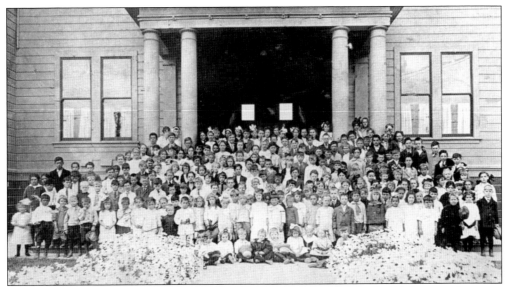

The entire school assembly poses on the steps of Albany School around 1913. In just a few more years, the school would become crowded enough to require that a second grammar school be built. (Courtesy of Albany Library Historical Collection.)

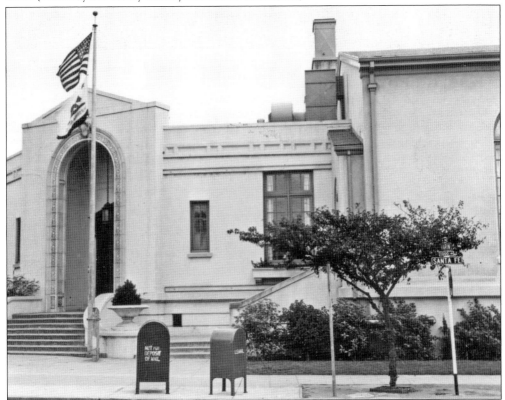

Marin School was established in 1917 at the corner of Marin and Santa Fe Avenues. The front entrance, which faced the corner, is pictured here in the 1950s. The building had a mauve color and became known to some as the "Pink Palace." (Courtesy of Albany Library Historical Collection.)

Above, a Marin School kindergarten class poses on the front steps of the school in 1934. Jewel (Nishi) Okawachi, who would later become an Albany business owner, city council member, mayor, and longtime community volunteer, is in the second row, fourth from left. Jewel's Terrace Park in Albany is named in her honor. Below, the 1967 graduating class of Marin School gathers at the same entrance. Those identified include Stanley Okawachi (first row, far right) and principal Betty Lott (second row, fourth from right). Others include Terri Nels, Chris Besette, and Debbie Muir. (Both, courtesy of Albany Historical Society.)

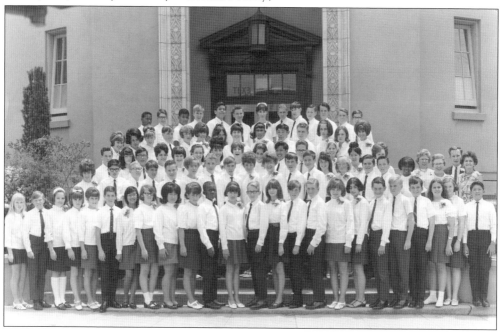

Construction of Albany High School began in the mid-1930s, built in stages on a "pay-as-you-go" basis to minimize taxes during the Depression. Prior to this, most older Albany students went to high schools in surrounding communities. (Courtesy of Albany Library Historical Collection.)

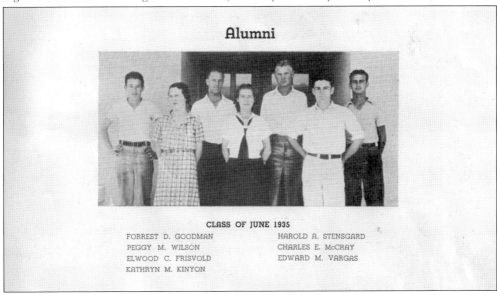

The first graduating class of Albany High School (1935) consisted of just seven students. As the school expanded, more students were added each year until full-size classes were achieved for all grades. (Courtesy of Anthony Golden.)

The old shop and band buildings (the latter once the First Baptist Church), which stood just south of the new Albany High School building, appear in this c. 1930s photograph. Note the small size of the trees planted on the Key Route Boulevard median strip. (Courtesy of Albany Library Historical Collection.)

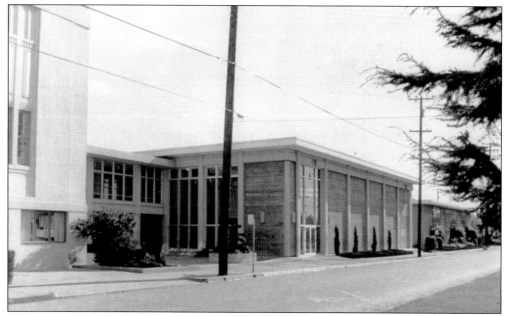

The area shown in the previous image looked quite different 30 years later. Here, the high school's East Alcove is shown in the mid-1960s. (Courtesy of Albany Library Historical Collection.)

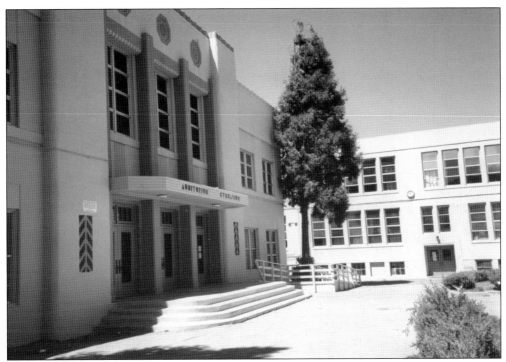

The old Albany High School auditorium/gymnasium was well known to generations of students and families who participated in and viewed events there. The building, first opened in 1941, is seen here in the late 1990s before it was demolished. (Courtesy of Albany Historical Society.)

A classroom and teacher appear in this photograph of the old Cornell School. The image was captured in the mid-1940s shortly before the demolition of the school. (Courtesy of Albany Library Historical Collection.)

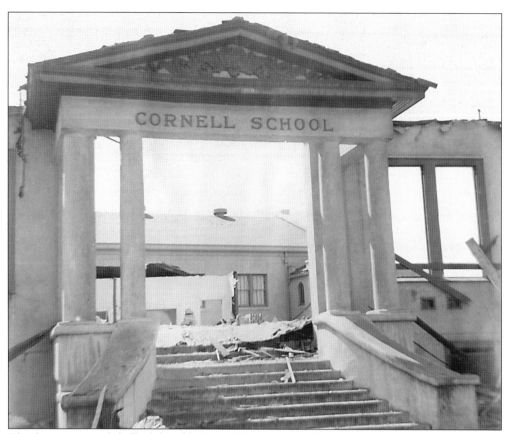

The front steps and shell of the old Cornell School were photographed as the school was torn down. The building was destroyed in 1946–1947 to make way for safer school structures. (Courtesy of Albany Library Historical Collection.)

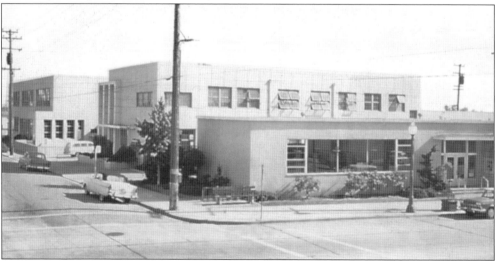

The new Cornell School buildings and district administrative offices are seen along Talbot Avenue in 1952. In the foreground is the new Albany Library, built at Talbot and Solano Avenues, the site of the old Cornell School building. (Courtesy of Albany Library Historical Collection.)

Vista School, at 720 Jackson Street, was one of two primary schools (along with MacGregor School, page 80) that were built in the late 1940s to help relieve overcrowding. Today, the school is used for the Albany Children's Center. (Courtesy of Albany Historical Society.)

The Marin School Junior Traffic Police gathered for a photograph in the early 1950s. In the front row at far right is Robert Golden Jr. Five generations of the Golden family have lived in Albany, beginning in 1926 with King Allen Golden; then Robert Sr.; Robert Jr.; Anthony, Mike, and Scott; and the latest generation, including Ashley, Jennifer, Nola, and Summer. Four generations of family members are Albany High School graduates. (Courtesy of Anthony Golden.)

Codornices Elementary School, located on Eighth Street, was built by the Federal Works Agency in 1944 for the children of Codornices Village, a federal housing project for war industry workers. The school, which was part of Albany's school district, had more than 800 students by 1945. (Courtesy of Albany Library Historical Collection.)

The Albany School Board gathered in the 1960s. From left to right are Kenneth Forry, superintendent; Rae Volz; Max Kelley; Charles Pinkham, president; Robert Nehls; and Milton Porter. (Courtesy of Albany Library Historical Collection.)

Teaching & Business Experience:
Accounting instructor,Merritt
College,since 1964. Staff ac-
countant and accounting su-
pervisor,California Farm Sup-
ply Co. and California Farm
Bureau Federation,1954-64.

Community Service: Cub Pack #3;
Albany Y-Indian Guides;Berke-
ley Boys' Work Association;
Albany Human Relations Com-
mittee.

VOTE ON APRIL 14

MEMBER, BOARD OF EDUCATION

ROBERT C. M. CHIN
Jr. College Instructor X

CHIN FOR SCHOOL BOARD
535 SANTA FE AVENUE, ALBANY, CALIF.

Bob Chin served on the Albany School Board for eight years during the 1970s, helping with a major school reorganization. He appears with his family in this 1970 school board campaign brochure. In the 1950s, the Chins had a difficult time buying a home in Albany as a minority family, but they eventually purchased a house in the Albany Terrace area. (Courtesy of Albany Historical Society.)

Albany Middle School opened at 1000 Jackson Street in 1976 following a major school reorganization that included rebuilding Marin School and portions of Cornell School. The site later became Ocean View Elementary School, now slated to be rebuilt in 2020 to meet current seismic safety standards. (Courtesy of Albany Historical Society.)

The area behind Albany High School was captured in this 1982 photograph. Originally this was Pomona Avenue, before becoming part of the school grounds. (Courtesy of Albany Library Historical Collection.)

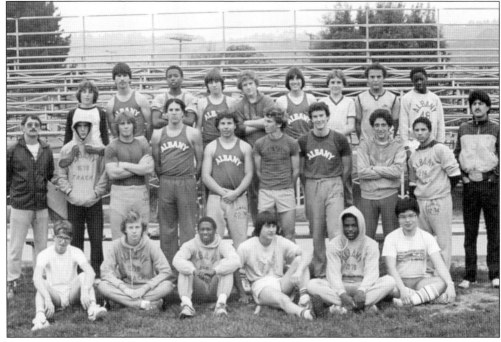

The Albany High School track team poses for a photograph in 1982. Track was a high school sport from the start, listed in the first yearbooks in the 1930s along with football, baseball, basketball, and tennis. Other sports were added later, as were increased opportunities for girls' athletics. (Courtesy of Albany Library Historical Collection.)

The late Ethel Hansen, daughter of Clara and Otto Lindstrom and part of a longtime Albany family, was the first Albany adult crossing guard. A bench was installed near Cornell School (where she worked for many years) in her honor. She appears here with her grandson Chris Kildegaard. (Courtesy of the Hansen family.)

An Albany PTA membership drive was conducted with the help of the Albany Fire Department in the 1950s. Here, a PTA member points to the "Member-ometer" constructed by the fire department. (Courtesy of Albany Library Historical Collection.)

Today, several groups support Albany schools, including the Albany Education Foundation, whose fundraising sign is pictured outside the school district's Enrollment Center. Other support organizations include SchoolCARE, Albany Music Fund, Albany Athletics Boosters, Albany Performing and Fine Arts Boosters, and the PTSA. (Photograph by the author.)

The Albany Middle School Annex opened in 2019 at the corner of San Gabriel and Brighton Avenues. The new building is one of four school improvement projects funded by bond measures B and E, passed by Albany voters in June 2016. (Photograph by the author.)

Eight

THE HISTORY OF THE SOLANO STROLL

"At least one day a year, Solano Avenue takes on more of a circus atmosphere than does Telegraph Avenue near UC-Berkeley," read a 1980 newspaper article. "Last week, thousands of people jammed the commercial avenue for the annual Solano Stroll. . . . entertainment was provided by scattered musicians, jugglers, fire eaters, magicians, belly dancers, clowns, mimes and other costumed creatures."

Lisa Burnham and Ira Klein, two Solano Avenue merchants, were probably pleased when they read this about the event they helped start in 1974 together with the Thousand Oaks Merchants Association.

According to Klein's son Gabe, Klein (now deceased) was influenced as a child by his cousin George Schindler, who grew up to be a well-known magician, comedian, and actor, starring as "Chandu the Great" in Woody Allen's *New York Stories*.

"As a child, my father watched his cousin perform magic tricks at several New York City amusement parks including Coney Island in Brooklyn," Klein said in a 2011 interview. "The carnival entertainment of my father's childhood and his 1960s college days at UC Berkeley—the Telegraph Avenue street vendors and counterculture performance artists—are two things that influenced him to organize the Solano Stroll in the early 1970s."

Another motivation he shared with the late Lisa Burnham was to help generate more business for Solano Avenue stores. Klein opened The Iris clothing/gift shop near the east end of Solano with his wife, Susan, around 1973, and Burnham had a nearby decorating/interior design business.

Burnham encouraged other businesses in the area to come together for the first Solano Stroll, which was more of a weekday evening sidewalk sale at the east end of Solano, said Sue Johnson, an early Stroll organizer who has operated a custom lamp and shade store at 1745 Solano Avenue for more than 47 years. The event featured music, a few entertainers, motorized cable car rides, and an ice cream stand from McCallum's, the much-loved ice cream parlor that was located at the site of today's Peet's Coffee. "It was like an afternoon/evening walk-around," Johnson said.

Henry Accornero, the original owner of Oaks Jewelers, which opened its doors at 1783 Solano Avenue in 1948, also remembers the first Solano Stroll. "A lot of people were not that familiar with Solano Avenue at the time," Accornero said. "We were trying to get people to see what was on the avenue and to come back and shop."

By 1981, the event switched to a Sunday afternoon in September and a community parade was added. Albany joined the event that year after a few merchants and restaurant owners came together to promote the idea, including Suzann Greer, the manager of Just Folks, a folk art and antique reproductions store in the 1400 block of Solano. At first the high cost of providing police protection for the event was a barrier for Albany, but the city decided to appropriate funds for police duties, and a permit for closing the street to Santa Fe Avenue was granted. Eventually, the street was closed all the way to San Pablo Avenue.

By the late 1980s, the Stroll was getting larger, attracting 15,000–20,000 people, and controversies developed. At that time, the Stroll had lost its direction and was nearly discontinued, according to the Solano Avenue Association, the Stroll's organizer (which replaced the Thousand Oaks Merchant Association). The event featured loud rock music and beer. Many of the merchants closed their shops and some nearby residents were unhappy with the commotion.

As a result, the Solano Avenue Association made changes, such as eliminating alcohol sales, encouraging more merchants to participate, and placing a greater focus on high-quality entertainment and art. Another move, controversial with some of the merchants, was adding outside booths and vendors to help fill in gaps along the street where businesses were closed.

For many years, the Stroll featured a theme, such as "Send in the Clowns" or "Journey of a Thousand Cranes," and each year a grand marshal—from local dignitaries to Howdy Doody—leads the parade. Various characters and entertainers have participated in the event over the years as well, ranging from a group of tap-dancing pickles to a Hawaiian ukulele group, fire-juggling unicyclists, taiko drummers, Brazilian dancers, bands from local schools, community choruses, and many others.

Attendance has soared from a few hundred people in the beginning to 100,000 in the late 1990s to 200,000-plus today, over the course of the day. According to the Solano Avenue Association, the Stroll—held annually for 45-plus years—now includes more than 500 vendors, including entertainers, food booths, handcrafters, non-profit and government organizations, and mechanical rides.

Today, the Stroll, far from a neighborhood sidewalk sale, draws people from all over the Bay Area. In the year 2000, the event was designated a Local Legacy at the Library of Congress American Folklife Center.

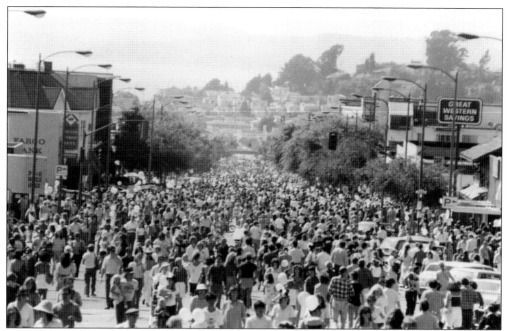

The Solano Stroll started in the mid-1970s as a small evening sidewalk sale at the east end of Solano Avenue in Berkeley. Over the next few years, it became a popular event that expanded down the street into Albany. This westward view from Berkeley shows the crowds gathered for the 1982 Stroll. (Courtesy of Albany Library Historical Collection.)

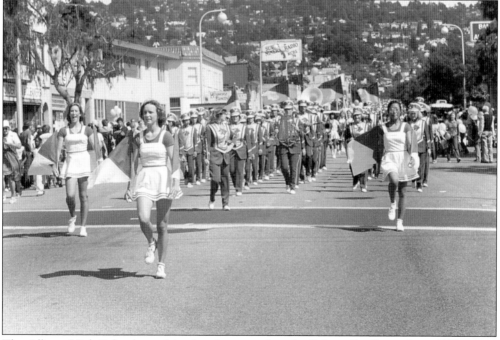

The Albany High School marching band appeared in the Solano Stroll parade in 1982, a year after Albany began participating in the event. The group is seen here near the Solano Avenue intersection with Curtis Street. (Courtesy of Albany Library Historical Collection.)

In 1986, the Albany YMCA seniors aerobics class was among the groups performing on the street during the Solano Stroll. McCallum's Ice Cream store, a longtime neighborhood favorite, can be seen in the background at the current location of Peet's Coffee. (Courtesy of Albany Historical Society.)

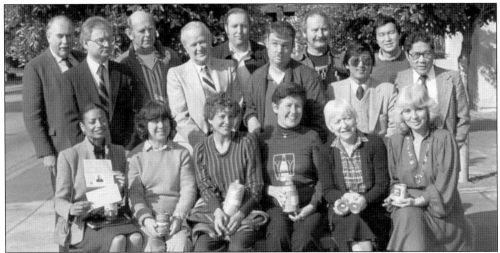

Members of the Solano Avenue Association gather with others to organize a food drive in 1983. The organization, which achieved nonprofit status the same year, organizes the Solano Stroll. From left to right are (first row) Cortese Sanders, Nancy Bissell, Joan Hangarter, Carol Walker, Elaine Ensler, and Roberta Conversano; (second row) John Sweeney, Tom Burcham, Bill Ortman, Bill Napolitana, Jim Gilmore, Bill Werner, Doug Walker, Al Satake, Kwan Lam Wong, and Yosh Takakuwa. (Courtesy of Albany Library Historical Collection.)

Stilt walkers have participated in the Stroll since the early years of the event in the 1970s. They continue to fascinate onlookers whenever they appear. (Courtesy of Tim Volz, Solano Avenue Association and Stroll.)

For many years, a popular feature of the Solano Stroll has been the creatively decorated "art cars" on display. This car was part of the 2005 Stroll. (Courtesy of Tim Volz, Solano Avenue Association and Stroll.)

Albany Preschool celebrates its 70th anniversary at the Solano Stroll. The preschool has been operating in Albany since 1937, first as a children's play program at Memorial Park, and then moving to its current location at 850 Masonic Avenue. (Courtesy of Solano Avenue Association and Stroll.)

Members of SchoolCARE participated in the Solano Stroll parade in the mid-2000s. The nonprofit organization, which was founded in 2001, raises funds for Albany Schools. (Courtesy of Tim Volz, Solano Avenue Association and Stroll.)

Local first responders participate in the Solano Stroll parade every year. Here, they pay tribute to the victims of the September 11, 2001, terrorist attacks and Hurricane Katrina. (Courtesy of Tim Volz, Solano Avenue Association and Stroll.)

The Albany-Berkeley Girls Softball League is a regular participant in the Solano Stroll. Founded in 1983, the league provides both recreational and competitive softball for girls in grades kindergarten through nine. (Courtesy of Solano Avenue Association and Stroll.)

Sixteen members of the Rhythm Bound band from Albany High School perform at a mid-2000s Solano Stroll. Various school groups are part of the Solano Stroll each year. (Courtesy of Solano Avenue Association and Stroll.)

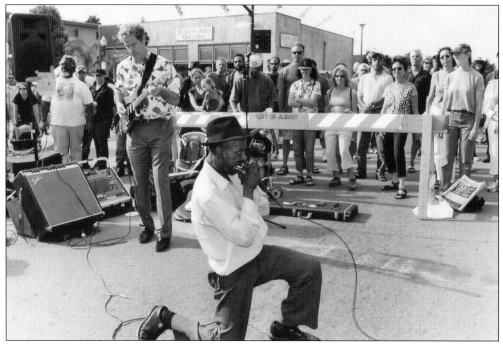

Musical entertainment has always been a key part of the Stroll. Here, a band performs for a crowd in front of the Albany Arts Gallery (now the Abrams Claghorn Gallery) at the Masonic Avenue intersection. (Courtesy of Tim Volz, Solano Avenue Association and Stroll.)

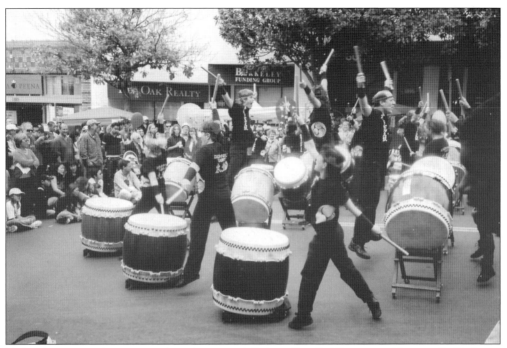

Taiko drummers draw a crowd at the annual Solano Stroll. The group, Emeryville Taiko, is performing at the east end of Solano Avenue in Berkeley, where the Stroll first began in the mid-1970s. (Courtesy of Solano Avenue Association and Stroll.)

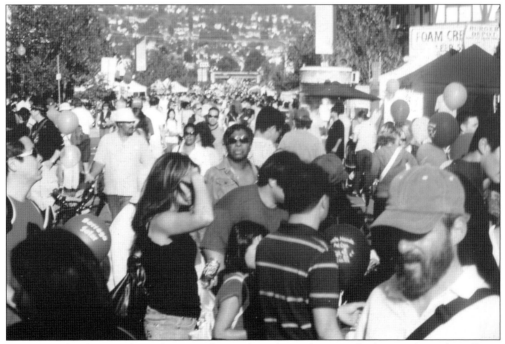

This street-level view of a Solano Stroll crowd in the early 2000s looks east from the Albany portion of Solano Avenue toward Berkeley. Many people who attend the Stroll say they enjoy running into friends and acquaintances. (Courtesy of Solano Avenue Association and Stroll.)

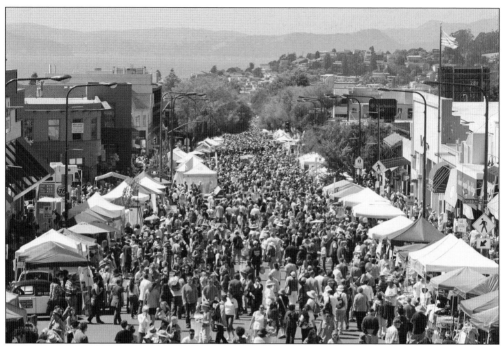

This westward view from the Berkeley end of Solano Avenue shows crowds filling the street for the 2012 Solano Stroll. Albany Hill and San Francisco Bay can be seen in the background. (Courtesy of Doug Donaldson.)

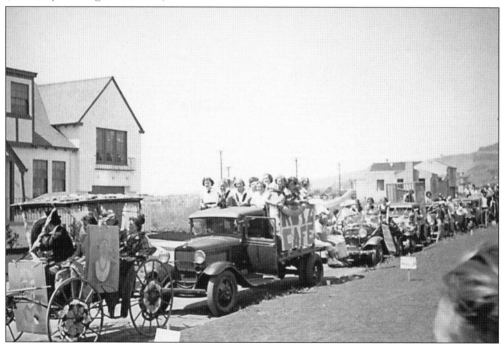

Before the Solano Stroll, another longtime tradition in Albany was the Fourth of July parade. Here, several early automobiles line up for the parade down an Albany residential street around 1918. (Courtesy of Albany Library Historical Collection.)

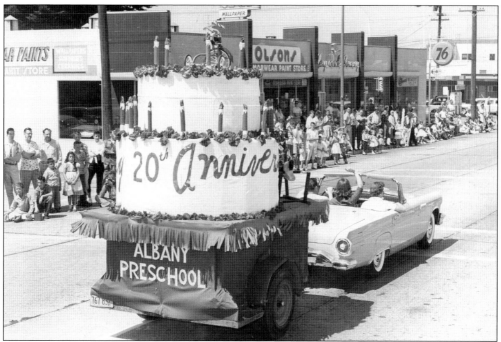

The 1957 Albany Fourth of July parade on Solano Avenue featured Albany Preschool's 20th anniversary float. In the background is the south side of the 1100 block where Olson's paint store and Foley and Bonny men's wear operated for many years. (Courtesy of Albany Historical Society.)

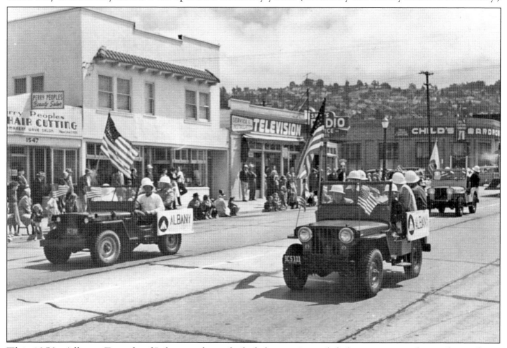

This 1950s Albany Fourth of July parade included the city's civil defense groups, shown here along the 1500 block of Solano Avenue. Civil defense groups were active in many cities during the Cold War following World War II. (Courtesy of Albany Library Historical Collection.)

Cheryl Ann Holstein, the Maid of Albany, appears in a parade in the mid-1970s. Driving the car, which is pictured at the intersection of Solano and Santa Fe Avenues, is Hal Denham of the Albany Chamber of Commerce. The winner of the annual Maid of Albany contest (sponsored by the Chamber from approximately the 1950s to the 1980s) would appear at ribbon-cutting ceremonies and various city events. (Courtesy of Albany Historical Society.)

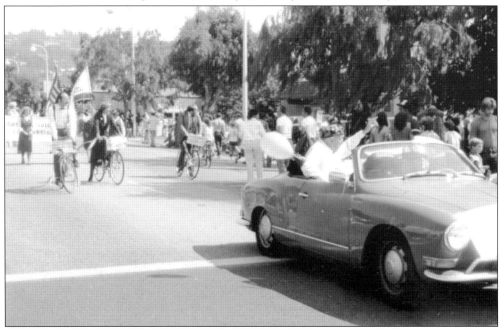

Albany's 75th Anniversary parade was held in September 1983. Former mayor Charles Graeber, the parade marshal, is seen in the car at right. Following behind on bicycles are Mayor Ruth Ganong, Vice Mayor Ed McManus, and Council Member Bob Nichols. (Courtesy of Albany Library Historical Collection.)

Albany city officials participating in the 75th anniversary parade include Mike Koepke, fire chief and Albany Rotary president (driving); Jacqueline Bucholtz, city clerk (back to camera); Joanne Keck Honer, treasurer; Bob Guletz, director of public works; and Robert Zweben, city attorney. (Courtesy of Albany Library Historical Collection.)

Three former mayors of Albany appear here during the city's 75th anniversary parade. Bill Lewis (driving), Robert Luoma (center), and Jerome Blank participated in the September 1983 event. (Courtesy of Albany Library Historical Collection.)

In this 1913 photograph of one of the first parades in Albany, a group of volunteer firemen march and wave the flag during the city's Fourth of July celebration. Albany Hill and the original Albany Methodist Church (today the Albany United Methodist Church) can be seen in the background. (Courtesy of Albany Library Historical Collection.)

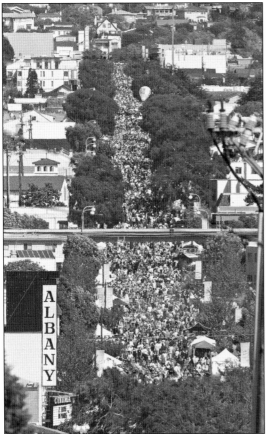

More than four decades after its beginnings as a sidewalk sale, the Solano Stroll now stretches a full mile along Solano Avenue from The Alameda in Berkeley to San Pablo Avenue in Albany. According to the Solano Avenue Association, the Stroll now attracts an estimated 200,000 people over the course of the day. (Courtesy of Doug Donaldson.)

Nine

ALBANY'S NAMESAKE HILL

Albany Hill, the prominent landmark named after the city in which it resides, did not always have such a straightforward name—and it has not had a straightforward history. In fact, the hill has had at least four different names that provide links to its intriguing past.

The Huchiun tribe of the East Bay area may have had a name for the hill, but it is unknown today. However, it is clear that Huchiuns frequented the area. The land near the base of the hill provided easy access to freshwater streams and nearby acorns and shellfish. It is here that visible evidence—mortar rocks and numerous shells in the soil—indicate the long-ago presence of a village or seasonal camp.

In the spring of 1772, Spanish explorer Pedro Fages and Father Juan Crespi led an expedition through the East Bay. On March 27, they camped on a creek near the hill (known today as Cerrito Creek). It was likely the Fages party that named the hill El Cerrito de San Antonio (the Little Hill of St. Anthony). Journal entries from the trip indicate that there were numerous bears in the area at that time, including one that was killed close to their camp.

By the early 20th century, the hill was commonly referred to as McKeever's Hill. This name, which frequently appears in old newspaper articles, may have referred to a local homesteader.

It was during this time (late 1800s–early 1900s) that dynamite manufacturers and at least one chemical company were located on and near Albany Hill, a place they considered a suitable, out-of-the-way location for their factories. But numerous deadly explosions proved incompatible with the growing population, and dynamite production in the Albany area was limited to 25 years.

It was not long before the hill was called Cerrito Hill, a shortened version of its original full Spanish name, but this actually translates to "Little Hill Hill." Cerrito was also one of the new names seriously considered for the city of Ocean View (Albany's original name), when the name was changed in 1909. (The nearby city of El Cerrito was not formed until 1917.)

In the early years of the 20th century, developers keen on selling East Bay property after the great San Francisco earthquake mapped out numerous lots in Albany, including neighborhoods called Sunset Terrace and Cerrito Hill on Albany Hill. Regent's Park, another large housing tract in Albany, included portions of the hill as well.

However, the hill developed more slowly than the level areas of the city, and for years was a favorite playground of Albany children. In the early years, children slid down the grassy slopes in wooden crate "toboggans," while later generations preferred cardboard. Longtime resident Gene Hellwig recalls riding his bicycle down the slopes of the hill in the 1930s.

In 1937, the Albany City Council officially changed the name of Cerrito Hill to Albany Hill. Over subsequent years a number of controversial developments were proposed.

One 1953 proposal suggested taking 200 feet off the top of the hill and building a fashionable "Nob Hill–style" development of 300 homes. A local newspaper article featured dramatic before and (simulated) after photos to help readers visualize the change. The plan was never approved.

Later that same year, the East Bay Municipal Utility District proposed cutting approximately 100 feet off the top of the hill and building a multimillion-gallon water reservoir. The proposal met strong opposition and was rejected.

In 1961, developer Golden Gate Heights, Inc., proposed a large $40 million project that also failed. The development was to start with a 12-story apartment building, later adding a hotel and much more. A news article stated that the developer "can see schools, hospitals, university buildings, office buildings, a shopping center—virtually a city in itself—as possible construction in the future."

Although other proposed large developments met a similar fate, the east and south sides of the hill began to fill in with residential housing.

One large-scale development that was controversial but eventually approved was the Gateview complex, which included seven high-rise towers built on the west side of the hill in the 1970s. The towers were a scaled-down version of the originally proposed development. The smaller-scale condominiums on Pierce Street were added in the 1980s.

Citizens' groups, including the Friends of Albany Hill, have been active at various times throughout the hill's history, advocating for open space. Eventually, Albany Hill Park and Creekside Park were established. (Other groups working to preserve areas on and near the hill include Tending the Ancient Shoreline Hill and Friends of Five Creeks.)

Today, the parks and adjoining areas of open space are home to eucalyptus trees (first planted during the years of dynamite manufacturing), monarch butterflies, a native oak forest, and many species of native plants.

Over the years, Albany Hill, in all its various designations, has stood more or less solid amidst various populations and change, even explosions. Today, the hill is a monument to East Bay and Albany history—natural and cultural. It continues to be a home for diverse people, wildlife, and plants, and the source of many memories and stories.

This 1861 photograph by Carleton Watkins is one of the earliest of the Albany area. El Cerrito de San Antonio (the Spanish name for Albany Hill) can be seen to the right. Note the lack of eucalyptus trees, which were planted later to buffer the explosions from the dynamite factories. Fleming's Point (today's Golden Gate Fields racetrack area) is to the left. (Courtesy of Albany Library Historical Collection.)

Another 1861 photograph shows the north side of Albany Hill. The road in the foreground is likely San Pablo Road. (Courtesy of El Cerrito Historical Society Collection.)

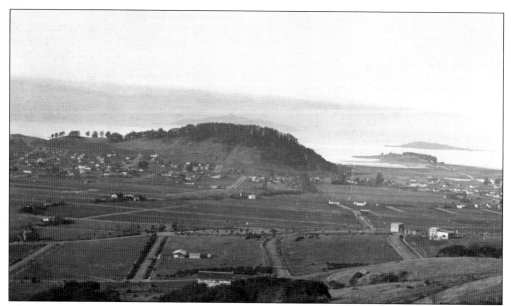

This c. 1915–1920 view looks southwest toward Albany and El Cerrito from the hills. A mostly undeveloped Albany Hill is visible near the bay shore. (Courtesy of Western Railway Museum Archives.)

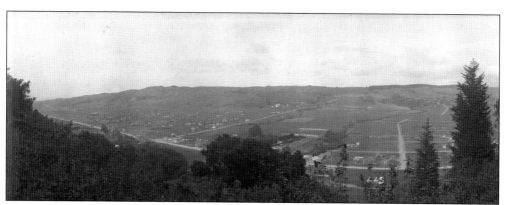

This northeast view from Albany Hill was captured during the early 1900s. The photograph shows San Pablo Avenue and the largely rural landscape of the Albany and El Cerrito areas. (Courtesy of El Cerrito Historical Society Collection.)

A seasonal camp or village of the Huchiun tribe likely existed near the base of Albany Hill, where mortar rocks (pictured) and shell fragments are still found today. The Huchiuns spoke Chochenyo, a dialect of one of several Ohlone languages. Today, the language is being spoken again by some of today's Ohlones. (Photograph by the author.)

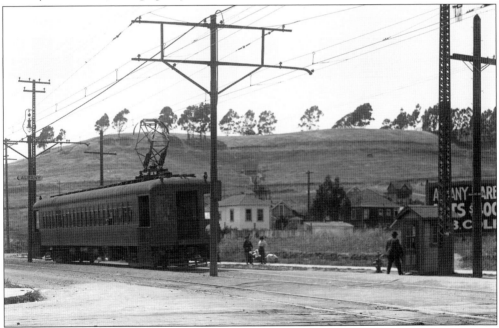

This c. 1912 view from the San Pablo Avenue and Main Street (Solano) intersection looks west toward the wide-open southern portion of Albany Hill. Also visible is a Southern Pacific electric train, part of the then newly established line on Solano Avenue. (Courtesy of Western Railway Museum Archives.)

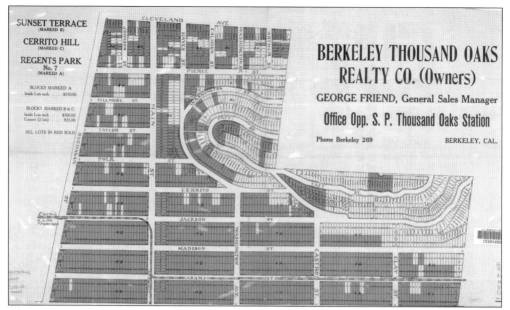

This c. 1917 map shows the early subdivisions of the Albany Hill area, including Sunset Terrace, Cerrito Hill, and Regent's Park. It also depicts the proposed Southern Pacific train line extension to Richmond along Adams Street, which was never built. (Courtesy of Earth Sciences and Map Library, UC Berkeley.)

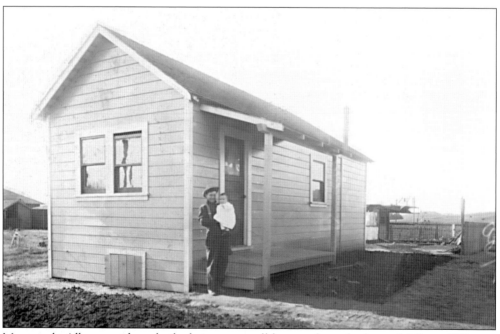

Many early Albany residents built their own small homes along the base of Albany Hill near San Pablo Avenue. Pictured is Clarence Rhodes holding Leona Stanley in front of his house on Adams Street around 1913. (Courtesy of Albany Library Historical Collection.)

This Solano Avenue home on the crest of Albany Hill was built around 1915 by Frank Olson, an Albany pioneer. When the family first moved to the house, they fetched water from a well on Polk Street and collected wood for cooking and heating from fallen eucalyptus branches on the hill. The fence pictured was built to keep out goats and cows that grazed and wandered on the hillside. (Courtesy of Albany Library Historical Collection.)

A woman enjoys the view of the bay from the south end of Albany Hill around 1938. In the background is the newly built Eastshore Highway (then just two lanes) and an unaltered Fleming's Point before the building of the racetrack. (Courtesy of the Marengo family.)

Wayne Van Winkle (third from right) and his brother Niel (second from left) were among the generations of children who have enjoyed playing on Albany Hill. They posed with a group of friends around 1943 on the west side of the hill. The boys were born in Albany and lived there several years. Later, their sister Gail returned to Albany while raising her own children. (Courtesy of Gail Van Winkle Lydon.)

Keith Marengo, who grew up on Madison Street in the 1950s–1960s, is pictured on the west side of the hill in 1955. "Albany Hill was my playground," he recalled. "I was constantly exploring and getting poison oak, and every summer the hill kids would slide down the dry grass on cardboard." (Courtesy of the Marengo family.)

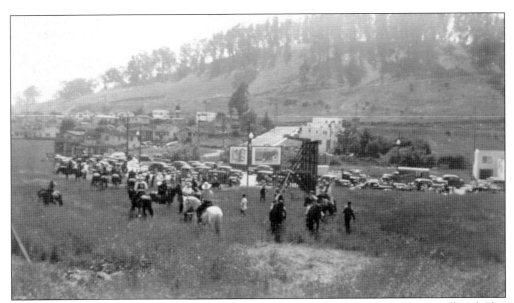

An equestrian group gathers near San Pablo Avenue in the 1930s–1940s. Albany Hill and Clay Street are visible in the background. The photograph was taken from the Brighton Avenue home of Henry and Mabel Dawson, who lived in Albany for decades. (Courtesy of Gail Van Winkle Lydon.)

An early 1960s view of the hill was captured in this photograph taken on Portland Avenue. Pictured is Bill Dorenzo, a member of an early Albany family. (Courtesy of Albany Library Historical Collection.)

In 1953, the East Bay Municipal Utility District proposed excavating the top of Albany Hill and removing some 1.5 million cubic yards of earth and rock to build a 77-million-gallon water reservoir. The illustration above shows that approximately 100 feet would have been removed from the hill. Below, a retouched "after" image was created to help Albany citizens and city council members visualize the change. The proposal met with strong local opposition and was never carried out. (Both, courtesy of East Bay Municipal Utility District, El Cerrito Historical Society Collection.)

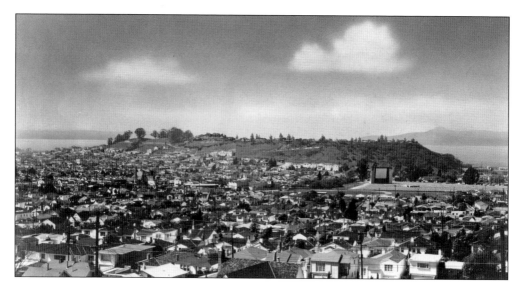

Another controversial development for Albany Hill was proposed in 1953 by realtor/developer C.H. Eccleston. This plan called for removing the top 200 feet of the hill and building a fashionable "Nob Hill–style" neighborhood with 300 homes. Before/after images were included in a *Berkeley Daily Gazette* article. Many local citizens were against the proposal, as they had been with several other large-scale developments suggested for the hill. (Courtesy of Albany Historical Society.)

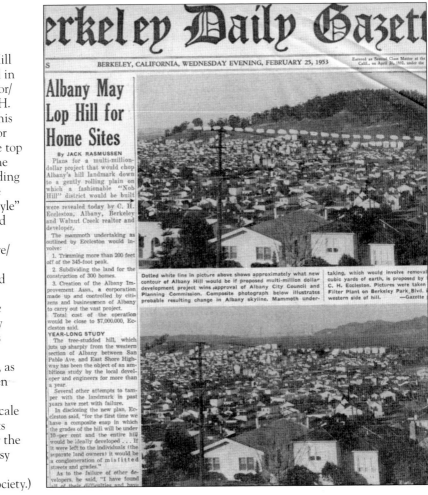

erkeley Daily Gazett

S BERKELEY, CALIFORNIA, WEDNESDAY EVENING, FEBRUARY 25, 1953

Albany May Lop Hill for Home Sites

By JACK RASMUSSEN

Plans for a multi-million-dollar project that would chop Albany's hill landmark down to a gently rolling plain on which a fashionable "Nob Hill" district would be built were revealed today by C. H. Eccleston, Albany, Berkeley and Walnut Creek realtor and developer.

The mammoth undertaking as outlined by Eccleston would involve:

1. Trimming more than 200 feet off of the 345-foot peak.

2. Subdividing the land for the construction of 300 homes.

3. Creation of the Albany Improvement Assn., a corporation made up and controlled by citizens and businessmen of Albany to carry out the vast project.

Total cost of the operation would be close to $7,000,000, Eccleston said.

YEAR-LONG STUDY

The tree-studded hill, which juts up sharply from the western section of Albany between San Pablo Ave. and East Shore Highway, has been the object of an ambitious study by the local developer and engineers for more than a year.

Several other attempts to tamper with the landmark in past years have met with failure.

In disclosing the new plan, Eccleston said, "for the first time we have a composite map in which the grades of the hill will be under 10-per cent and the entire hill would be ideally developed . . . If it were left to the individuals (the separate land owners) it would be a conglomeration of misfitted streets and grades."

As to the failure of other developers, he said, "I have found

Dotted white line in picture above shows approximately what new contour of Albany Hill would be if proposed multi-million dollar development project wins approval of Albany City Council and Planning Commission. Composite photograph below illustrates probable resulting change in Albany skyline. Mammoth undertaking, which would involve removal cubic yards of earth, is proposed by C. H. Eccleston. Pictures were taken Filter Plant on Berkeley Park Blvd. western side of hill. —Gazette

This southwest view shows Albany Hill as it appeared in the early 1970s. Visible in the background is the long Berkeley Pier where ferries once docked, and downtown San Francisco. (Courtesy of Albany Library Historical Collection.)

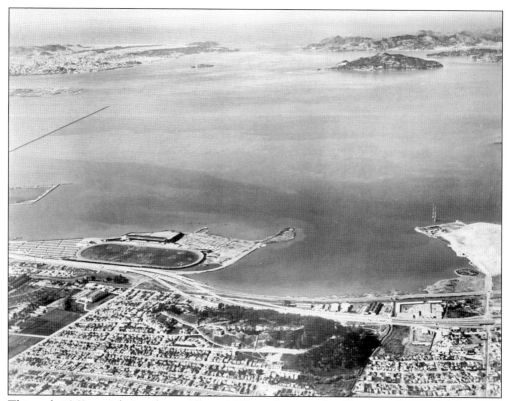

This early 1960s aerial view shows Albany Hill in relation to San Francisco Bay and the Golden Gate. Also visible is the Golden Gate Fields racetrack and the beginnings of the Albany Bulb, where dumping occurred for many years. (Courtesy of Albany Library Historical Collection.)

The Gateview condominium complex was a controversial development built on the west side of Albany Hill in the mid-1970s. The seven towers constructed were a portion of the original, larger development proposal. The smaller condominium units to the left were added along Pierce Street in the mid- to late 1980s. (Courtesy of Doug Donaldson.)

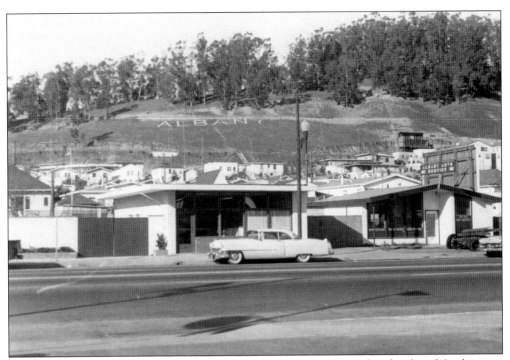

In the early 1950s, much of the upper portions of Albany Hill remained undeveloped. In this view from the 700 block of San Pablo Avenue, the word "Albany" is seen on the hillside. (Courtesy of Albany Historical Society.)

A similar view captured in the late 1980s shows how the hill was filling in with housing. Albany Subaru, in the foreground, still operates in the same block today. (Courtesy of Albany Historical Society.)

Catherine's Walk is a staircase on Albany Hill named after the late Catherine Webb, once a hill resident and activist. Webb helped start the *Albany Community News* in the 1970s and founded the first Albany Historical Society. The author of the history book *Stories of Albany*, she donated her collection of historical photographs to the Albany Library in 1994, three years before she passed away. (Photograph by the author.)

The trail through Albany Hill Park is seen in the fog along the top of the hill. Albany Hill Park, Creekside Park, and various areas of open space have helped preserve some of the hill's undeveloped areas. More recently, a neighborhood children's playground—Peggy Thomsen Pierce Street Park, named after a former Albany mayor—was added near the southern base of the hill. (Courtesy of Doug Donaldson.)

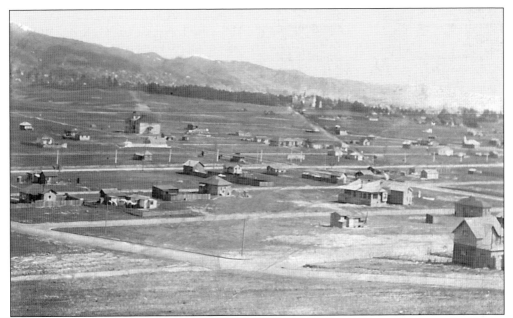

Albany Hill has always provided a vantage point for viewing the city of Albany. In 1909, a photographer ascended the hill to Cerrito Street near Washington Avenue and captured this image of the new city. Visible is the intersection of San Pablo Avenue and Main Street (Solano), Albany School (upper left), and the Peralta Park Hotel (in the distance). (Courtesy of Albany Library Historical Collection.)

A recent photograph taken near the same location as above captures a modern nighttime view of Albany. A multitude of lights shine, illustrating the city's transformation over more than 110 years from a rural, open landscape to the "Urban Village" of today. (Courtesy of Doug Donaldson.)

DISCOVER THOUSANDS OF LOCAL HISTORY BOOKS FEATURING MILLIONS OF VINTAGE IMAGES

Arcadia Publishing, the leading local history publisher in the United States, is committed to making history accessible and meaningful through publishing books that celebrate and preserve the heritage of America's people and places.

Find more books like this at
www.arcadiapublishing.com

Search for your hometown history, your old stomping grounds, and even your favorite sports team.